GW01372802

JAPANESE CLOISONNÉ:
THE SEVEN TREASURES

VICTORIA & ALBERT MUSEUM • FAR EASTERN SERIES

JAPANESE CLOISONNÉ: THE SEVEN TREASURES

GREGORY IRVINE

Photography by Ian Thomas

V&A Publications

First published by V&A Publications, 2006
V&A Publications
Victoria and Albert Museum
South Kensington
London SW7 2RL

Distributed in North America by Harry N. Abrams, Inc., New York

© The Board of Trustees of the Victoria and Albert Museum 2006

The moral right of the author has been asserted

ISBN 1 85177 482 3 (ISBN 13: 9781851774821)
Library of Congress Control Number 2005 035870

10 9 8 7 6 5 4 3 2 1
2009 2008 2007 2006 2005

A catalogue record for this book is available from the British Library.

All rights reserved. No part of this publication may be reproduced, stored in a retrieval system, or transmitted in any form or by any means electronic, mechanical, photocopying, recording or otherwise, without written permission of the publishers.

Designed by Andrew Shoolbred
New V&A photography by Ian Thomas, V&A Photographic Studio

Front jacket illustration: Lidded vase, page 103
Back jacket illustration: Vase, page 92
Title page: Vase, page 77
Half-title page: Vase, page 53
Contents page: Vase, page 99

Printed in China

V&A Publications
Victoria and Albert Museum
South Kensington
London SW7 2RL
www.vam.ac.uk

Contents

Acknowledgements 6

Statement from Edwin Davies OBE 8

Introduction 10

Notes 36

Edwin Davies Cloisonné Collection 37

Glossary 140

Bibliography 141

Index 143

Acknowledgements

The foundation for this book is the Japanese cloisonné enamel collection of Mr Edwin Davies, OBE. Mr Davies has formed a superb collection of this craft with objects ranging in date from the so-called Golden Age (c.1880–1910) to those made since the late 1960s. Mr Davies is a good friend of the V&A, and we were very fortunate to have been able to exhibit a selection of cloisonné from his collection in the Toshiba Gallery in 2002–3. This book is, in effect, a further development of that joint enterprise.

Mr Davies's collection is particularly strong in cloisonné enamels made in Nagoya during the Taishō period (1912–26), especially by the Andō Company. The V&A has no examples of cloisonné from this company, except for one unsigned piece, or indeed from many of the other Nagoya makers that are so well represented in the Davies collection. What the V&A does have are fascinating and well-documented examples of cloisonné representing the early period of the craft's renaissance in Japan. These have been used in this book to complement Mr Davies's collection. The book follows the format of an introductory essay that outlines the development of cloisonné enamels in Japan, illustrated by examples from the V&A's collection, followed by a catalogue of the Davies collection.

Mr Davies is one of a small but steadily growing group of individuals worldwide, both in museums and the private sector, who are diligently working towards achieving recognition for the arts and crafts of the Meiji period and later. The study of Japanese cloisonné enamels is particularly important for the understanding and appreciation of the arts of this period. This publication is not an exhaustive work on the subject and there is much scope for further research and writing in this field. I hope, however, that this book will inspire others to continue to research the field and to promote this wonderful art form.

I have been fortunate to have had a great deal of help and assistance with my research into Japanese cloisonné from many people both in this country and in Japan. In Japan, I should first like to thank Mr Mikio Ogawa of the Nagoya City Museum, perhaps Japan's foremost authority on Japanese cloisonné enamels, for sharing so much of his time and expertise, and for showing me some superb examples of Japanese cloisonné; also for the assistance of his colleagues Ms Tomoko Hata and Mr Yoshihiro Inoue. At the Tokyo National Museum, Mr Yoshiaki Itō for the same reasons as Mr Ogawa, and Ms Tomoe Kreiner for help during my visits to Japan. Above all Mr Yūji Dainobu (now at the new Kyūshū National Museum) for inviting me to Japan (through his museum's scheme for inviting foreign researchers) and arranging all the details of my visit. As well as enabling me to see the museum's splendid collections, this timely visit made it possible for me to see three wonderful exhibitions of Japanese cloisonné that I would otherwise have missed.

Further help through access to collections was provided by Ms Aya Ohta and Mr

Takashi Okamoto at the Museum of the Imperial Collections (Sannomaru Shōzōkan). The ever-helpful and extremely knowledgeable Ms Hiroko Yokomizo of the Tokyo University of Fine Arts and Music, with whom I have shared ideas and research over many years, also gave me access to their collections. At the Kyoto National Museum, Mr Tomoyasu Kubo, an ever-helpful and friendly colleague, showed me his museum's collections and shared his extensive knowledge of the subject. Also in Kyoto, Ms Atsuko Morito and Ms Yukari Mutō of the Namikawa Museum along with Mr Masayuki Murata, Director of the Kiyomizu Sannenzaka Museum, shared their time and showed me their wonderful collections. At the Inaba Company in Kyoto, I was fortunate to meet on several occasions two generations of makers, Mr Inaba Hiroyuki and his father Inaba Katsumi, whose knowledge and reminiscences must surely be recorded for posterity.

Thanks also to Mr Atsushi Hirose of Shōsenkyō, near Kōfu, who showed me his superb private collection of cloisonné. To Mr Jūrō Andō, CEO of the Andō Cloisonné Company, and to his colleague Mr Yoshida, a former maker of cloisonné and a fount of knowledge and anecdotes about cloisonné. Finally to my long-term friends Toyoko and Hiroshi Kondō, who always make my visits to Japan enjoyable.

In Europe, I would especially like to thank Mr Malcolm Fairley for sharing his time, enthusiasm and extensive knowledge with me, and his long-time collaborator and expert (the word is not used loosely) in the area of Meiji-period art, the late Dr Oliver Impey. Mitsuko Watanabe and Hiromi Miyauchi have helped me with reading difficult Japanese inscriptions. I should also like to thank colleagues at the Natural History Museum in London for help in identifying plants and birds as they appear on cloisonné, in particular Dr Joanne H. Cooper of the Natural History Museum Bird Group. Thanks to Andrew Keelan at the Kibo Foundation for providing me with excellent source material, to Filip Suchomel, formerly of the National Gallery in Prague, and to Monika Bincsik of the Ferenc Hopp Museum of Eastern Asiatic Arts, Budapest, for sharing information on their collections of Japanese cloisonné.

I should like to thank my colleagues in the Asian Department at the V&A, particularly Dr Rupert Faulkner, with whom I have worked closely on this project. Thanks also to the Research Department for enabling me to have exclusive time to complete research and writing. Many thanks to my colleague Ian Thomas of the V&A Photo Studio for taking the superb photographs to be found in this book. Special thanks to Edwin and Susan Davies for giving me free access to their collections, and to Gilly Wheatley for everything she did to ensure that the time spent researching on the collections was a rewarding and enjoyable one. Finally, as always, to my long-suffering family, Harriet, Dan and Grace, who have stoically endured my absences while researching and isolation while writing the book – many thanks.

Statement from Edwin Davies OBE

I was first introduced to cloisonné in the early 1990s by my good friend Tom Brindle. What attracted me was not only the design and beauty of the objects, but also the manufacturing techniques. Having an engineering background and with business interests in South-East Asia, the art form intrigued me: the more pieces I acquired, the more I learned about their manufacture and the more I became determined to form a fully representative collection.

I have followed the development of cloisonné from China to Japan and have seen how the art form was intertwined with the major political events that unfolded at the end of the Edo period and through the Meiji and Taishō periods. The opening up of Japan by Captain Perry and the stimulus to the technology provided by Gottfried von Wagener, together with the determination, dedication and great artistic talent of the Japanese enamellers, were all factors in the rise of this superb craft.

My collection contains more than a hundred pieces and focuses on the late nineteenth and early twentieth centuries, when cloisonné reached its apogee with the attainment of the 'porcelain dream' by my favourite artist, Namikawa Sōsuke. I was fortunate enough to exhibit part of my collection at the Victoria and Albert Museum in late 2002 under the title *Enamelled Wonders*. This book, which builds on that initiative, is intended to enable a wider audience to see the collection in its entirety.

I must thank Gregory Irvine and Rupert Faulkner of the V&A, together with the Director, Mark Jones, for organizing this publication. I hope that you enjoy it as much as I have enjoyed building my collection.

Edwin Davies OBE

Introduction

There are two distinct qualities or types expressed in Japanese art: one suggesting endless patience in the execution of minute detail, the other denoting a momentary conception of some fleeting idea carried out with boldness and freedom of expression in form and line – profuse complexity and extreme simplicity … the work on Japanese cloisonné ware generally exhibits the quality suggestive of unwearying labour and patience.[1]

The characters for the word *shippō* in the Japanese term for enamelware, *shippō-yaki*, mean 'Seven Treasures', which is a reference to the seven treasures mentioned in Buddhist texts. Although these treasures may vary, they generally include at least some of the following: gold, silver, emerald, coral, agate, lapis lazuli, giant clamshell, glass and pearl. The Japanese applied this expression to the rich colours found on Chinese enamel wares and those that they later made themselves.

Although Chinese enamelled vessels had been imported and highly valued since at least the seventeenth century, there was little production of three-dimensional cloisonné enamel objects in Japan until well into the nineteenth century. There are, however, a few debatable larger-scale cloisonné objects that could have been made in Japan at an earlier date. The ewer shown here (Plate 1) would, on both technical and stylistic grounds, normally be dated to around 1860–70, but an identical object currently held at the Kyoto National Museum has been dated by some Japanese authorities to the late eighteenth century or the early nineteenth (Plate 2). The decoration on both pieces is of the mythical *Hō-ō* (phoenix) and flaming Buddhist jewels among stylized clouds.[2]

From rather tentative beginnings in Nagoya in the 1830s, by the end of the nineteenth century the production of modern cloisonné enamels had expanded to become one of Japan's most successful forms of manufacture and export. There was a huge increase in the production of cloisonné enamel ware following the 'reopening' of Japan in the 1850s and the ensuing obsession in the West for all forms of Japanese art. Foreign merchants had only been permitted to trade from the port of Yokohama since 1859. Stories are told that the cloisonné maker Hayashi Kodenji (1831–1915) would walk from Nagoya to Yokohama to sell his wares. There was a long-standing prohibition on selling copper (which in this case comprised the body of the cloisonné objects), but Kodenji realized that there was an excellent market for his wares to be found among the foreigners who were buying up whatever Japanese art they could find. This suggests that it was in the 1860s that the export trade in Japanese cloisonné enamels began to develop.

The peak of artistic and technological sophistication was reached during the years 1880–1910. This period is often referred to as the Golden Age of Japanese enamels. During this time there were literally hundreds of workshops of varying sizes and

degrees of ability working to satisfy demand from what was predominantly a Western export market. It was to be some time, however, before cloisonné enamels were deemed to have sufficient artistic merit to be in high demand in Japan itself. Writing in 1911, Harada noted that

> It is only in comparatively recent years, most markedly within the last few years, that shippō began to find a place in Japanese homes as an ornament. As is so often the case with arts and crafts, there are two distinct types of enamel-work, one for foreign markets and the other for the home market … [3]

Following the downfall of the samurai-led government and the restoration to power of the emperor in 1868, Japanese artisans, particularly metalworkers, lost their traditional patrons and had to find new markets for their skills. As Japan strove to throw off its feudal past and develop as a modern industrialized and economic power, so the West, which until then had seen very little Japanese art except lacquerware and porcelain made for export, suddenly developed a voracious appetite for the artistic products of the country. Adopting the slogan *Wakon Yōsai* ('Japanese spirit, Western knowledge'), Japan employed Western technicians and advisors to work with Japanese craftsmen on the introduction of new and improved methods of production.

Serendipitously, this was also the time when great exhibitions were being held all over the world. These were occasions when countries such as Japan could show off their skills in the arts, crafts and other manufacturing industries. In addition to these official events, there were also unofficial exhibitions and displays of Japanese art, such as those

Plate 1
Hot water ewer (*yutō*). Unsigned, c.1800–60. Height 18.3 cm. V&A: 227–1896, from the collection of Lord Leighton.

Plate 2
Illustration showing the *yutō* in use, from *Onna ichidai fūzoku ehon masu kagami* [Customs and morals in the lives of women] by Nishikawa Sukenobu, 1748.

at the Japanese Village in London. This was a commercial enterprise that operated between 1885 and 1887 in a purpose-built exhibition hall (Humphrey's Hall) located near Knightsbridge Green. The village was a working entity with authentic houses and shops occupied by Japanese craftsmen and their families (Plate 3). Many traditional crafts and skills could be seen at the village, and visitors included the designer Christopher Dresser and W. S. Gilbert, who sought advice from the inhabitants of the village on various aspects of Japanese culture, such as personal deportment and the use of the fan, for his production of *The Mikado*, which opened at the Savoy Theatre in London on 14 March 1885.

In 1878 Sir Rutherford Alcock, one of Britain's first diplomats in Japan and organizer of the Japanese display at the London International Exhibition of 1862 (where he exhibited many Japanese works of art from his own collection), commented on cloisonné enamels in the following terms:

> Their patterns are generally intricate and minute, small sprays, flowers, diapers, and geometrical figures all being laid under contribution, while leaves of various colours – drab, white, light green are interspersed. These being minutely subdivided, it is impossible not to be struck with admiration at the marvellous delicacy of execution and fertility of invention, if not of imagination, displayed. Such works would simply be unproducible in any country where skilled workmanship of a high order, and artistic in kind, was not abundant and obtainable at exceedingly low rates of remuneration. Many of the enamel works must represent the labour of years, even for two or three hands.[4]

Plate 3
'Making cloisonné enamel' at the Japanese Village, London. From *The Illustrated London News*, 21 February 1885.

It is clear from this detailed description that by the 1870s the manufacture of cloisonné enamels was burgeoning into a full-scale concern (Plate 4).

Another commentator on Japanese cloisonné of this period was James Lord Bowes. He had personally acquired a large collection of Japanese art, including numerous pieces of cloisonné enamels, and was among the earliest collectors in the West to write in detail on the subject. He had extremely adamant views about the history and development of Japanese cloisonné, almost all of which were wrong. He classified Japanese enamels into groups, which, under his scheme, placed many objects in the eighteenth century, or even the seventeenth. While his views were criticized by many of his contemporaries for being totally out of keeping with what was already known at the time, many of his ideas persisted right up to the late twentieth century, with writers such as Sir Harry Garner attributing pieces to earlier periods in Japanese history.

In 1901 Captain Frank Brinkley, an astute observer of the arts of Japan, criticized Bowes in the following terms:

> Mr Bowes maintained his views with remarkable firmness. No Japanese collection, public or private, contained any specimen of the wares which he supposed to have been produced and preserved in temples and noblemen's residences during nearly three centuries. No Japanese connoisseur had any knowledge of such objects having been manufactured previously to 1837 ... Some of the specimens which Mr

Plate 4
Group of six vases showing the basic processes of cloisonné manufacture. Unsigned; 1800–1900. Each vase height 8.9 cm. V&A: 174–1901.

Bowes attributed to the seventeenth century were unhesitatingly identified by artisans of the present time as their own work, and the signatures which certain of the specimens bore were claimed by the men who had actually signed them ... he clung to that theory with a tenacity which, considering the testimony on the other side, is probably unique.[5]

It was probably due to the experimental nature of Japanese cloisonné production during these early years, and the fact that the vessels being made were often imitations of Chinese originals of earlier periods, that there was a supposition by many Westerners – as we have seen in the case of Bowes – that what they were looking at was ancient, when in fact the objects were frequently more or less contemporary. In her presentation to the Japan Society in 1906, Charlotte M. Salwey explained:

> Today in some manufactories you may find specimens that bear all the appearance of great antiquity, with all the subtle cunning and workmanship of earlier archaic energy, but should you inquire of the master of the factory if he could furnish you with an approximate date of manufacture, he will smile a pleasing smile as he courteously makes answer 'These honourable pieces that you inquire about have just been withdrawn from the kiln today.'[6]

So successful was cloisonné as an art form that huge quantities of low-standard products began to flood the export market, causing interest in these wares to decline towards the end of the nineteenth century. Writing as early as 1884 in his privately published *Japanese Enamels*, Bowes commented as follows:

> The modern enamels of Japan merit only a passing notice ... At Yokohama, at Nagoya, in the province of Owari, and, I believe, at Kioto [sic] also, the industry is now carried on upon a large scale by native workmen, but mainly under French directors, who, studying what they suppose to be the requirements of the European market, have produced works deficient in beauty of form, colouring and workmanship.[7]

Bowes's concerns were echoed by the cloisonné maker Namikawa Sōsuke (1847–1910). A publicity brochure issued by Sōsuke reproducing an article from the *New York Herald* of 9 February 1896 includes extracts from interviews with him that reflect the state of enamel production in Japan. The article is captioned 'Japanese Cloisonné: The great Namikawa, of Tokyo, describes the development of his art in the last two decades'. Sōsuke is quoted as follows:

> I regret that the wide-spread demand for Japanese products in your country has created an awkward confusion and lack of discrimination as to what should be classed as commercial commodities purely and what should be given rank as aesthetic creations. For instance, my work is regarded as too expensive, and it certainly is when classed with the ordinary Cloisonné on the market; but I assure you that under my system, when the labor, time, repeated failures, &c., incident to turning out a perfect gem are taken into consideration my valuations are not at all exorbitant. Not a

piece leaves my hands that does not represent many attempts and failures and which is not the result of patient toil, well-nigh despairing.

It is clear that by 1896 the production of cloisonné enamel in Japan had become the victim of its own success. The almost overwhelming demand for enamels was resulting in the production of cheaper wares purely for export, and the craft had begun to have a reputation for cheapness and shoddiness. A combination of cheap cloisonné enamels combined with overproduction resulted in a decline of the industry, which was as rapid as its ascent. Again, Harada is the most astute observer of this effect:

> The shippō industry is already suffering a heavy penalty – at least that class of ware which depended solely upon the capricious demand of the West co-existent with ignorance of the Japanese and their ideals. Let us take as an illustration the case of Tōshima, a village a few miles from Nagoya. It is known properly by another name, that of *shippō-mura*, which means 'village of cloisonné wares' ... at one time the inhabitants of shippō-mura turned out no less than seventy per cent of the total cloisonné enamels produced in Japan. But nearly all the kilns in Tōshima are now idle and their workshops closed, while the annual output of Japanese cloisonné has dwindled during the last six years [1905–11] to less than one-third of what it used to be. The appearance of the village was almost unbearable to the writer when he visited it nearly two years ago ... it is our belief that the keynote tragedy lies in the misconception of Western needs and the flooding of Western markets with cheap, low-class wares.[8]

Despite the decline in the production and export of cloisonné enamels to the West, the craft persisted in Japan. Cloisonné enamels continued to be produced for the Imperial Household, and the major companies that were still in production after 1920 (chiefly Andō and Inaba) had a reliable domestic market. In 1957 the technique of cloisonné enamelling was selected as an 'Intangible Cultural Property for which documentation and other measures should be taken'. This is different from the designation 'Important Intangible Cultural Property', whereby the recognition is of a particular individual or group. The types of work being produced today and exhibited in the annual *Nihon Dentō Kōgeiten* (Exhibition of Japanese Traditional Art Crafts) tend to be relatively traditional in terms of technique and form. Although the general perception of cloisonné enamels in Japan remains poor (reflected in the home craft industry catered for by magazines such as *How to Cloisonné*), some modern makers are breaking with tradition and are producing highly innovative and challenging enamelled works.

It was, and is still, in the West where many of the best collections of Japanese cloisonné enamels are to be found and where the impetus to acknowledge the artistry and skills of enamel craftsman has mostly come from. The forming, exhibiting and publishing of these superb collections have led the Japanese to re-evaluate Japanese cloisonné and the arts of the Meiji period more generally. In the past few years in Japan itself there have been several important and popular exhibitions that have focused on this period. They have, significantly, created a greater awareness of the importance of Japan's contribution at the great world expositions.

Early Enamels in Japan

One of the earliest examples of enamelwork to have survived in Japan is a mirror in the collection of the Shōsōin, the repository of imperial treasures in Nara.[9] There has been much controversy over the date and provenance of this unusual object: China, Korea and Japan have all been posited as places of manufacture, with dates ranging from the eighth century AD to the early seventeenth. The method of manufacture and exactly how the enamels were applied to the mirror have also been the subject of much debate.[10] Other than this rather anomalous object there are relatively few examples of early Japanese enamelling except for some small door fittings with enamelled designs in the Phoenix Hall (dedicated in AD 1053) of the Byōdōin Temple in Uji, to the south of Kyoto, and the cloisonné-enamel-decorated architectural fittings used by the *shōgun* Ashikaga Yoshimasa (1436–1490) when building his Higashiyama retreat in eastern Kyoto (now the Ginkakuji temple).

Plate 5
Door pull (*hikite*) of the four-lobed shape known as *mokkogata*, decorated in champlevé (*zōgan*) enamels. Unsigned; c.1700. 9.1 x 8.0 cm. V&A: M.283–1912.

Plate 6
Decorative nail cover (*kugikakushi*) decorated in cloisonné and champlevé enamels with a central iron plaque. Unsigned; c.1750–1800. 8.8 x 6.2 cm. V&A: M.293–1912.

Plate 7
Water-dropper (*suiteki*) decorated in cloisonné enamels with cloud-motifs and stylized floral scrolls. Unsigned; c.1700–1800. Height 4.1 cm, length 8.7 cm. V&A: M.80–1912.

It was not until the late sixteenth century that cloisonné enamels became more widely used in Japan. As in earlier times, enamelling was employed primarily on architectural fittings, for example door pulls (*hikite*) (Plate 5) and decorative nail covers (*kugikakushi*) (Plate 6). Many of these early enamels were not true cloisonné in that they used few, if any, wires, but were executed in the technique known as *champlevé*. This is where an area of the ground or body of an object is carved away and the resulting void filled with enamels: this is known in Japanese as *zōgan*. Cloisonné enamelling in the proper sense of the word was, however, used at this time for the decoration of water-droppers (*suiteki*) (Plate 7), which were part of writing sets and used in the preparation of ink.

The most significant application of true cloisonné enamelling during the pre-modern period was in the production of metal fittings for arms and armour. At a time of almost constant warfare and political instability, the metalworkers of the late sixteenth century produced excellent works under the patronage of the military. There was a great demand for fine decoration of swords and their associated accoutrements, and enamelling techniques were employed to produce decoration on sword fittings, such as *tsuba* (sword-guards). The finest of these were made by the Hirata School, which was founded by Hirata Dōnin (also known as Hirata Hikoshirō), who died in 1646. The school was

active, through a subsequent eleven generations, well into the second half of the nineteenth century.

It is important to note that the work of the Hirata School involved making small enamelled components, generally using gold wires to create the design and often with a gold background to add to the reflective qualities of the enamels, which were then applied or inlaid into the soft metal of the sword fittings (Plate 8). While the quality of the work of the Hirata School was generally very high, by the nineteenth century the term Hirata was also used to refer to much less refined work in the style of the school but made by other craftsmen. Writing in 1895, Bowes mentions that 'In more recent days, members of the family [Hirata] have been employed by the Imperial government as medallists'.[11]

Plate 8
Sword-guard (*tsuba*) of brass (*shinchō*) with applied cloisonné enamel decoration in gold wire. Signed Hirata Harunari (died c.1840?) with an art signature (*kakihan*); c.1800. 6.8 × 6.4 cm. V&A: M.596–1916, Alexander gift.

The Manufacture of Japanese Cloisonné Enamels

Enamelling, as previously noted, is a meticulous and extremely time-consuming craft. The enamels themselves are a form of glass coloured with metallic oxides and applied as a paste to what is usually a metallic body. When the object is fired in a kiln to an appropriate temperature, the glass melts and fuses to the body. The object is then cooled and its surface is polished to a high-gloss finish. There are various enamelling techniques. The simplest is the one mentioned earlier, *champlevé*, whereby a pattern or design is carved out of the body of a metallic form; the enamel paste is applied into the resulting hollow; and the piece is then fired and polished. In cloisonné enamelling fine wires are used to delineate the areas (*cloisons* in French, hence *cloisonné*) into which the enamel paste is applied. The wires serve a dual function: they can be an integral part of the decoration at the same time as preventing the molten enamels from flowing, during firing, into adjoining areas of the polychrome design.

The production of cloisonné enamels requires a body, generally of copper (although silver and gold can be used), onto which a design is first drawn in ink. Fine wires, usually of brass, gold or silver (which can be of different thicknesses), are then bent or hammered into the required shape and carefully glued (traditionally with glue made from the lotus root) along the lines of the ink design. This process is followed by the gluing on of small pieces of solder or the covering of the whole body with a thin layer of flux. The vessel is then fired to a low temperature to fuse the wires to the body. The next stage involves the application with a spatula or bamboo stick of the variously coloured enamel pastes into the cloisons, the wires of which sit proud of the surface of the body (Plate 9). After the removal of any surplus paste, the object is ready for its first firing, this usually being carried out at a temperature of between 800 and 900 °C.

During firing the paste both melts and contracts. This means that in order to achieve an enamel coating of the same thickness as the wires, the process of applying enamel paste and firing has to be repeated

Plate 9
Applying enamel paste to a vase at the Shippō-chō Shippō yaki Art Village, near Nagoya. Photograph by Gregory Irvine.

Plate 10
Set of mounted cloisonné specimens demonstrating some of the processes in the manufacture of cloisonné enamels. The top panel shows a range of the different colours of enamel available to the maker. Unsigned; c.1880. Each tray 12.0 × 8.5 cm.
V&A: 19–1883, Gift of Messrs Lyons, Marcus & Co.

several times. Additional firings may be required because some enamels have different melting points. In order to counter the effects of heat stress, what is referred to as a counter-enamel is generally applied to the inside of the object. After each firing, any surplus hardened enamel is removed and the marks left by this process, together with any pit-marks or air bubbles that have formed, are ground down before the next layer of enamel is applied. Finally, after all the cloisons have been filled with fired enamels to the required depth, the surface of the vessel is ground until the edges of the wires are visible and then the whole piece is polished. The grinding and polishing process involves the use of many different grades of stone and can in some cases take several months or even longer to complete (Plate 10). In another finishing process the craftsman may gild the visible edges of the wires to create an even more refined finish. Needless to say, some vessels do not always survive this process of repeated firings and the success rate can at times be quite low.

The Renaissance of Japanese Cloisonné and the Major Makers of the Golden Age

One thing, however, is certain; namely that until the nineteenth century enamels were employed by the Japanese decorators for accessory purposes only. No such things were manufactured as vases, plaques, censors or bowls having their surface covered with enamels applied either in the champlevé or the cloisonné style … prior to the year 1838.[12]

The renaissance of Japanese cloisonné manufacture is usually credited to Kaji Tsunekichi (1803–1883) of Nagoya in Owari Province (modern Aichi Prefecture), a former samurai turned metal-gilder (Plate 11). Kaji, like many other samurai of the early nineteenth century, was forced to find ways to supplement his meagre official stipend. It is not known whether he knew of the work of the Hirata School of enamellers, but even if he did there would have been little possibility of his finding out any of their techniques, because Japanese craftsmen jealously guarded their manufacturing secrets. It is believed that Kaji found, or bought from a dealer, a piece of Chinese cloisonné enamel. By taking it apart and examining how it was made, eventually, around 1838, he managed to produce a small cloisonné enamel dish. Then, according to Brinkley's summary of Kaji's own account of his career, 'he now applied himself with patient assiduity to work of this kind, and succeeded, in 1839, in making a plate six inches in diameter' (Plate 12).[13]

Plate 11
Shippōyaki hatsumei-nin Kaji Tsunekichi shōzō ['Portrait of Kaji Tsunekichi, inventor of *shippōyaki*']. Private collection, copyright Nagoya City Museum.

Plate 12
Kaji Tsunekichi's toolbox. Private collection, copyright Nagoya City Museum.

Kaji then turned his hand to the production of other small items such as brush-rests and cups, and very soon 'had the honour of seeing his productions presented to the Tokugawa Court in Yedo by the feudal chief (*daimyō*) of Owari'.[14] By the late 1850s – although there is some debate over the precise date – Kaji had been appointed official cloisonné maker to the *daimyō* of Owari. The bowl and dish shown here with their relatively thin copper bodies and thickly applied muddy-coloured cloisonné enamels with brass wires are very reminiscent of the early attempts at larger three-dimensional forms created by Kaji (Plate 13).

Basing his designs on the motifs and colour schemes of Chinese cloisonné enamels, Kaji drew upon the resources and expertise of other metalworkers and potters (who had

Plate 13
Bowl decorated with stylized flowers (including lotus or *Hōsōge*) and fine *karakusa* wires, and dish with two dragons on a ground of clouds and *karakusa* scrolls. Unsigned. Nagoya, 1855–65. Bowl height 8.3 cm, diameter 17.2 cm; dish diameter 20.9 cm. V&A: 249+a–1904, bequest of Eleanor Watt.

Plate 14
Covered bowl with decoration of central panels containing sea-shells and seaweed on a ground decorated with peony and fine *karakusa* and floral scrolls. Unsigned; 1860–75. Height 20.9 cm, diameter 23.2 cm. V&A: M.584–1911.

the skills required to fire his enamel pieces) to realize his ambitions. He still had many technical difficulties to overcome, particularly in the application of the enamels, and his early works, like those of other makers of the time, are characterized by the use of a larger number of background wires. These were both decorative, in that they formed an integral part of the design, and practical, in that they prevented the enamels from running during firing. The patterns created by the wires on many of these early pieces often took the form of stylized waves, clouds, key-fret patterns and scrolling *karakusa* (literally 'Chinese grass') (Plate 14). Although the ground and other enamels of this covered bowl are of a dull colour, the brass wires are here more decorative and less functional than earlier examples of cloisonné and can therefore be seen to represent some of the rapid advances in Japanese enamelling from Kaji's earlier efforts.

The few extant works that can definitely be attributed to Kaji include a small cup in the collection of the museum in the Shippōyaki Art Village near Nagoya[15] and a 'temple bowl' in the Shōmyōji Temple in Nagoya.[16] The latter was exhibited by the Shippō Kaisha of Nagoya in the Second Industrial Exposition of 1881, although apparently with no mention of the name of Kaji.[17] Early pieces of cloisonné enamel like these still tended to have heavy bodies and thickly applied enamels, with colours that were muted and muddy in appearance. In some instances the cloisons failed to contain the enamels, which then bled into each other, although this can create a not unattractive effect. The delicate vessel shown in Plate 15 has similarities to the 'temple bowl' attributed to Kaji. It shows distinctive Chinese influence both in its style of decoration and in the use of wires and enamelling.[18]

By the mid-1850s Kaji was sufficiently confident to start taking on pupils. These included Hayashi Shōgorō (died 1896), a craftsman mainly celebrated for the fact that his pupils were in turn the teachers of many of the later masters of cloisonné enamelling. The most important of Hayashi's pupils was Tsukamoto Kaisuke (1828–1887), who studied under him during the period 1860–61.[19] It is said that Hayashi was a traditionalist who never revealed the

Plate 15
Water container (*mizusashi*) decorated with a curious mythical beast (perhaps a dragon), stylized lotus (or *Hōsōge*) flowers and geometric motifs. The base carries the Japanese character *raku* ('pleasure') in red enamel. Unsigned. Nagoya, c.1870. Height 9.9 cm, diameter 14.1 cm. V&A: M.437–1910.

22 JAPANESE CLOISONNÉ: THE SEVEN TREASURES

Plate 16
Porcelain bottle decorated with abstract floral and geometric motifs of cloisonné enamel on a blue enamel ground. Unsigned. Nagoya, c.1870–80. Height 17.2 cm. V&A: 4364–1901.

Plate 17
Lidded porcelain container, possibly for tea (*natsume*) with details of interior. Signed on the base *Dai Nihon Aichi ken Hara Fujio Zō* ('made by Hara Fuji of Aichi prefecture in Great Japan'). Nagoya, c.1870–80. Height (with lid) 10.2 cm. V&A: M.21–1958, Gift of Sir Harry Garner.

secrets of his formulae (or sources) even to his closest students, and that Kaisuke had to discover for himself that the blue material used by his master as a ground enamel was in fact 'ready-made blue glass'.[20]

Kaisuke's own experiments enabled him to create a picture of Nagoya Castle on a plate, the first time a purely representational design had been realized in cloisonné enamels. Kaisuke is also believed to have been responsible for the discovery, around 1868, of how to apply cloisonné enamels to a ceramic vessel. Brinkley noted: 'Since 1868 the Owari potters have introduced an entirely novel method of decorating porcelain, by cloisonné enamelling.'[21] This was a relatively short-lived innovation, however, and was never very popular, probably because enamels on porcelain tended to be dull and dirty in appearance and were liable to crack. Nevertheless, some fine and durable examples were produced (Plate 16).

The container shown here (Plate 17) is of exceptionally fine quality and is decorated on the lid in silver wires with two quail among flowers, a band of stylized bats and clouds and a band of scrolling *karakusa*. The body bears a band of scrolling *karakusa* with the main decoration of plovers. The interior has been given a thin wash of either brown lacquer or enamel and then decorated with gold and silver lacquer birds, flowers and abstract geometrical motifs. The interior foot has the signature in gold lacquer. Tsukamoto Kaisuke in his turn taught Hayashi Kodenji (1831–1915), a craftsman who was to become one of the most influential cloisonné makers of his time. Kodenji set up an independent cloisonné workshop in Nagoya in 1862 and, like his teacher, began to train other craftsmen. He remained at the forefront of cloisonné manufacturing in the Nagoya region throughout his career.

In 1871 the Nagoya Cloisonné Company (Nagoya Shippō Kaisha) was established at Tōshima, just outside Nagoya, by Muramatsu Hikoshichi and Tsukamoto Jine'mon, the elder brother of Tsukamoto Kaisuke. The technological advances they made resulted in the company winning a first prize at the Vienna Exhibition of 1873.[22] So many cloisonné-manufacturing companies sprang up in and around Tōshima that the area, which rapidly became Japan's main centre of cloisonné production, came to be known as Shippō-mura (Cloisonné village) or Shippō-chō (Cloisonné town) (Plate 18). It has been estimated that at their peak the cloisonné manufactories of Tōshima were producing 'no less than seventy percent of the total cloisonné enamels produced in Japan'.[23]

By 1875 Tsukamoto Kaisuke had left Nagoya to become the chief foreman of the Ahrens Company in Tokyo. This was one of many companies set up under the new Meiji government's programme whereby Western specialists were invited to Japan to help modernize the country's existing industries. The chief technologist of the Ahrens Company, which had exhibited one of Kaisuke's works at the Vienna Exhibition, was the German chemist Gottfried Wagener (1831–1892). Wagener, an expert on glazes and firing techniques, is renowned for having introduced modern European enamelling technology to Japan. Between them he and Kaisuke were responsible for many of the crucial innovations on which the subsequent success of the Japanese cloisonné enamel industry was to depend.

The Japanese-German collaboration gave rise to new enamels with a wider range, depth and intensity of colours. Finishes were improved and far higher levels of gloss were achieved than had been previously possible. Innovations introduced by Wagener

Plate 18
Monument at Shippōyaki Tōshima, erected in 1895. *Shippo yaki gensanchi, Takaramura no uchi Tōshima* ('The original place of manufacture of *shippō*: Tōshima in the village of Takaramura'). Photograph by Gregory Irvine.

obviated the need for background wires to retain the enamels, the way thus being opened for the application of clear bright enamels over large unbroken areas of the vessel surface. No longer were potentially distracting patterns of circles, abstract patterns and *karakusa* scrolls required for technical reasons: the creation of more realistic and painterly designs in enamels was now possible.

In 1878 Wagener moved to Kyoto. That same year, or early the next, the Ahrens Company closed down, obliging Kaisuke to return to Nagoya. He found employment with the Nagoya Cloisonné Company, where the expertise he had gained through working at Ahrens was greatly welcomed. In Kyoto, Wagener met the former samurai and cloisonné artist Namikawa Yasuyuki (1845–1927). Yasuyuki began his career about 1868 and worked with the Kyoto Shippō Kaisha from 1871 to 1874. Then, having established his own studio, he began to exhibit his work at national and international expositions: Philadelphia in 1876, the First National Industrial Exposition in Tokyo in 1877 and Paris in 1878.[24] Although it is not clear how Wagener and Yasuyuki met, there is no doubt that they collaborated and that the most significant result of their collaboration was the creation of the superb semi-transparent mirror-black enamel that was to become the hallmark of most of Yasuyuki's subsequent work. This enamel can be seen clearly on the small lidded vase shown in Plate 19. Although the interior of the foot on this object carries a silver plaque with the well-executed signature of Namikawa Yasuyuki, the design and execution of the ducks are perhaps more reminiscent of the work of Shibata of Kyoto.[25]

Yasuyuki's cloisonné enamels are characterized by the skilful use of intricate wirework and superb attention to detail. The designs on his earlier pieces are relatively traditional, consisting mainly of stylized botanical and formal geometric motifs. The designs on much of his later work tends to be more pictorial, consisting mainly of scenes from nature and views of landmarks in and around Kyoto. His work included both pieces with designs predominantly defined by wires and pieces where the pictorial composition is balanced by large areas of pure coloured enamel.[26]

It was to Yasuyuki's studio that many Western travellers to Japan ventured, often leaving extensive descriptions of what they saw. One such account is by Rudyard Kipling:

Plate 19
Lidded vase decorated in silver wires with flowers, including peony and iris by a stream, two flying ducks and a butterfly.
Signed *Kyoto Namikawa*.
Kyoto, c.1890. Height 13.6 cm.
V&A: 266-1903.

It is one thing to read of cloisonné making, but quite another to watch it being made. I began to understand the cost of the ware when I saw a man working out a pattern of sprigs and butterflies on a plate about ten inches in diameter. With the finest silver ribbon wire, set on edge, less than a sixteenth of an inch high, he followed the lines of the drawing at his side, pinching the wires into tendrils and the serrated outlines of leaves with infinite patience … With a tiny pair of chopsticks they filled from bowls at their sides each compartment of the pattern with its proper hue of paste … I saw a man who had only been a month over the polishing of one little vase five inches high. When I am in America he will be polishing still, and the ruby-coloured dragon that romped on a field of lazuli, each tiny scale and whisker a separate compartment of enamel, will be growing more lovely. 'There is also cheap cloisonné to be bought,' said the manager with a smile. 'We cannot make that. The

vase will be seventy dollars.' I respected him for saying 'cannot' instead of 'do not.' There spoke the artist.[27]

Charlotte Salwey, writing in 1906, also described Yasuyuki's work and studio:

> Namikawa of Kyoto revels in the true cloisonné and charms by means of floral and arabesque designs, in which wealth and harmony play their own important parts. His men work in companionship, surrounded by scenery, peaceful and full of symbolic suggestion, calculated to elevate the mind and impart religious and helpful lessons to the patient workers labouring over their tedious tasks. This thoughtful precaution is a part of the master's scheme of education [Plate 20].[28]

One of the most detailed descriptions of Yasuyuki and his workshop is to be found in Herbert Ponting's *In Lotus Land Japan*. Ponting, who devoted an entire chapter to the subject, echoed Salwey's somewhat romantic view of the conditions of cloisonné production.[29] Having characterized Namikawa as a 'man of quiet speech and courteous manner, whose refined classical features betrayed in every line the gentle, sympathetic nature of the artist', Ponting then described the view from Namikawa's house:

> Outside was a narrow verandah fronted with sliding windows of glass, and beyond was the essence of all that is aesthetic and refined in a Japanese garden. There was a little lake with rustic bridges, and miniature islands clad with dwarf pine trees of that rugged, crawling kind that one sees only in Japan … [Plate 21].[30]

In terms of the atmosphere within the workshop itself, Ponting observed:

Plate 20
'Stereograph no.69. Expert workmen creating exquisite designs in cloisonné, Mr Namikawa in the background. Kyoto, Japan. Underwood & Underwood, 1904.' V&A: E.70–1993.

Plate 21
'Stereograph no.70. South over gardens from the home of Mr Y. Namikawa, the famous leader in art-industries. Kyoto. Underwood & Underwood, 1904.' V&A: E.71–1993.

Plate 22
Namikawa Yasuyuki's *kanban* (shop sign), now at the Namikawa Museum, Kyoto. Photograph by Morito Atsuko.

Each member of staff has absorbed the master's ideas from his earliest acquaintance with the art; and although Namikawa now does little work himself except designing and firing he closely supervises each piece during its entire execution ... His artists do not work by set hours, but only when the mental inspiration is upon them ... as I passed that little unobtrusive shingle at the gate, with its simple inscription 'Y. Namikawa, Cloisonné' how truly typical it was of the unaffected modesty of real genius [Plate 22].[31]

By all accounts Yasuyuki was much more easy-going than other producers and was more than happy to entertain the steady stream of Western visitors who called on him. The environment of his studio, which survives today as the Namikawa Museum – its garden largely unchanged since Ponting's time – was, and still is, both relaxing and serene.

Yasuyuki strove to improve both his technical and artistic skills and continued to exhibit his cloisonné wares at the National Industrial Expositions. There is speculation that he also exhibited at the Chicago Exhibition of 1893. In 1896 he was appointed Imperial Craftsman (*Teishitsu Gigei'in*) to the court of the Emperor Meiji. This was an important position and guaranteed a domestic market for his work while simultaneously increasing its value and price. Yasuyuki retired in 1915 and his company closed soon afterwards. Many of his designs and preparatory drawings have been recorded in the *Kyō Shippō Monyō Shū* (Kyoto Cloisonné Pattern Collection) and examples will be referred to later in the catalogue section of this book.

Namikawa Sōsuke (1847–1910) was another important cloisonné artist who was also appointed Imperial Craftsman to the court of Emperor Meiji in 1896. Much to the confusion of contemporary Western visitors to Japan, Sōsuke and Yasuyuki were unrelated, the family name of Namikawa being written with different characters. Sōsuke originally worked for the Nagoya Cloisonné Company but later moved to run their branch of the company in Tokyo. There is some confusion as to the precise nature of Sōsuke's relationship with the company: Impey and Fairley state that he had taken over the company in 1880, Coben and Ferster that he did not build a factory in Tokyo until 1887.[32] In the publicity brochure mentioned earlier that quotes the *New York Herald* article, there is an extract from the reports of the judges of the Third National Exhibition, Tokyo, of 1890, which states that 'in April of the following year (1880) the [Nagoya Cloisonné] Company established a factory at Ushigome, Tokyo, and placed it under the management and superintendency of Mr S. Namikawa'.[33]

Sōsuke was an active contributor to both national and international expositions. He won prizes at the Universal Exposition in Amsterdam in 1883, at the Nuremberg International Metalwork Exhibition in 1885, and at the Exposition Universelle in Paris in 1889. He had in his employ Jinsuke and Jinkurō, the two sons of Tsukamoto Kaisuke, and it was due to them that Sōsuke's distinctive style of cloisonné enamel decoration

began to develop. Thanks to their technical expertise, Sōsuke was able to perfect a distinctive style of decoration in which his enamelled designs gave the appearance of reproductions of ink paintings. The two techniques he used, which are called *shōsen* and *musen*, depended on the development of enamels that would not bleed into each other even when they were not separated by wires. In the case of *shōsen* (literally, 'few, or limited, wires'), the number of wires was kept to a minimum and they were used only to delineate small details, while in *musen* (literally, 'no wires') the wires were removed prior to the final firing. It is perhaps stating the obvious that forms such as plates and plaques created a flat surface on which the enamels would be less likely to run, but the technique was also successfully employed on vases and other three-dimensional forms. In addition, the term cloisonné, with regard to these particular developments, now becomes somewhat redundant, since this style of enamelling did not employ cloisons.

One may ask why Sōsuke and those who followed him took such pains with this painstaking process when Japanese porcelain manufacturers had for some considerable time been able to reproduce painterly effects with far less effort. There is probably no one answer, but certainly reproductions of paintings in enamel can have greater depth of colour and subtlety of tone than their ceramic equivalents. One can also speculate that in an age of international exhibitions, Japan was keen to show off to the rest of the world its ability to master such an incredibly complicated and laborious technique.

Sōsuke both reproduced historical paintings and worked closely with contemporary painters, notably Watanabe Seitei (1851–1918). At the World's Columbian Exhibition of 1893 he exhibited his famous *Mount Fuji among the Clouds*, a large plaque in wire-less shaded enamels now in the collection of the Tokyo National Museum. This subject was reworked by Sōsuke in a number of versions and was also copied by other manufacturers.[34] It was at about this time that Sōsuke, a man not shy to tell the world about his achievements, began to use the *sakigake* (literally 'pioneer') seal on his work. While there is uncertainty about precisely when Sōsuke made many of the various technical innovations for which he is accredited, or indeed took self-credit, there is no doubt that he raised Japanese enamelling skills to new and truly remarkable heights.

Of the many companies that were producing in Nagoya and the surrounding area, including Shippō-chō, none was more influential and productive than the Andō Company, founded in Nagoya by Andō Jūbei. Its foreman from 1881 to 1897 was Kaji Satarō, the grandson of Kaji Tsunekichi. He was succeeded by Kawade Shibatarō (1856–1921?), who introduced and developed the numerous technical innovations on which the Andō Company's success was based. The most important of these – which is sometimes credited to Hattori Tadasaburō, another Nagoya-based maker, rather than Kawade – is known as *moriage* (literally, 'piling-up'). This painstaking technique, which required extreme care, especially at the polishing stage, involved building up layers of enamel to produce a three-dimensional effect. It was ideally suited to natural subjects such as plants and flowers, but was used for the depiction of other subject matter as well.

Harada's description of the Andō Company mentions that as well as having 'one large factory' Andō 'also has many artists in different parts of Nagoya and Tōshima working exclusively for him'. Kawade is given particular mention:

[Andō's] reputation was established chiefly by the splendid work turned out by his chief enamel artist and designer, Kawade Shibataro, who is deservedly considered the greatest enamel expert in the manufacture of shippō at the present time. Perhaps no other living person has done more towards the improvement of Japanese enamels and the invention of new methods of application than Kawade.[35]

The precise nature of the relationship between Kawade and Andō is not clear. There are works that have Kawade's mark within the Andō mark, while others bear Kawade's mark alone. Yet other pieces bear only the Andō mark and are clearly by Kawade.[36] Kawade left the Andō Company in 1897 to set up his own manufactory in Kobe, making copies of Chinese cloisonné enamels for the industrialist Kawasaki Shōzō.

Another important development of the early 1900s was the use by the Andō Company of the enamel technique known as plique-a-jour (*shōtai-jippō* in Japanese). Andō Jūbei had seen examples of this at the Paris Exposition of 1900 and had brought back with him a piece by Fernand Thesmar. This was analysed by Kawade, who perfected and then further developed the technique. In *shōtai-jippō* an object is prepared as if for cloisonné enamelling, though sometimes with the wires being fixed only by glue. The interior, importantly, is not enamelled, thereby increasing the failure rate through additional stresses during the firing process. Once the piece has been completed, clear lacquer is applied to its polished exterior to protect it from the acid that is then used to dissolve the copper body. The result is an object, usually rather fragile, that consists of semi-transparent panels of enamel held together by a pattern of fine wires. The popularity of *shōtai-jippō* led to the technique being adopted by many other manufacturers, mainly in the Nagoya area (Plate 23).

The Andō Company won many prizes at world exhibitions, starting with the World's Columbian Exposition in Chicago in 1893. A little later, around 1900, it was appointed as an official supplier of cloisonné to the Imperial Household. Although no single craftsman was given the title of Imperial Craftsman, the Andō Company was the main provider of enamel works for dispensing as imperial gifts. The Andō Company is unique, furthermore, in that it is the only manufacturer with its roots in the 'Golden Age' that is still producing high-quality cloisonné enamels today.

Until its closure in the 1990s, the Inaba Company of Kyoto was another important survivor of the Golden Age. It was founded in 1886 by Inaba Isshin, a former low-ranking samurai from Ehime who had started working in enamels in 1875 (as with Namikawa Yasuyuki, to supplement his meagre stipend). His art name, Nanahō, is a play on the word *shippō*, the characters for which can be also be read as Nanahō (Plate 24). The company's output was rather eclectic and combined designs and techniques used by other Kyoto makers together with those of Nagoya manufacturers, particularly Andō and Hayashi Kodenji. The third- and fourth-generation heads of the family, Inaba Katsumi and Inaba Hiroyuki, still live in Kyoto and are invaluable sources of information about the history of cloisonné-making in Japan. The family's archives, together with tools and enamelling materials, are preserved in the Museum of Kyoto (*Kyoto Bunka Hakubutsukan*). Their old workshop, however, was demolished in 2004 and turned into a parking lot – a sad reflection on the demise of an industry that produced the glorious objects illustrated in this book.

Plate 23
Shōtai-jippō vase decorated with silver wire chrysanthemums in polychrome enamels, applied silver rim and baseplate. Unsigned. Nagoya, c.1910–20. Height 6.2 cm, maximum diameter 9.7 cm. V&A: M.206–1917, Henry Louis Florence bequest.

Plate 24
Portrait of Inaba Nanahō, courtesy of Kinunken, the Inaba Cloisonné Company.

Collecting Japanese Cloisonné at the Victoria and Albert Museum

The V&A was established with the purpose of forming collections that would 'exhibit the practical application of the principles of design in the graceful arrangement of forms, and the harmonious combination of colours for the benefit of manufacturers, artisans and the general public'. From the outset it collected objects from many different cultures, its first Japanese acquisitions being a group of modern Nagasaki lacquerware bought from Hewitts and Co. of Fenchurch Street, London, in 1852. The first examples of Japanese cloisonné enamels acquired by the V&A came from the Paris Exposition Universelle of 1867. These are thought to be the earliest documented examples of Japanese cloisonné enamels in the West. They include a 'kettle' (Plate 25), bought for £24, and a 'sweetmeat case' (Plate 26), for which an even higher and at those times extraordinary sum of £60 was paid. Both pieces are recorded as having been purchased from 'The Tycoon's government' and were described as 'antique Japanese'.

The 'Tycoon's government' was, of course, the Tokugawa *shōgunate* in its final days of power. The vessels were either contemporary or had been made within the previous ten years, therefore representing some of the earliest examples of larger-scale cloisonné made in Japan since the efforts of Kaji Tsunekichi, the founder of Japan's modern cloisonné industry. Both pieces are characterized by dull enamels on a blue ground and the use of large numbers of background wires. We do not know who made them, but they are likely to have been produced in Nagoya, possibly even by Kaji.

In the years 1872 and 1875 two dishes were purchased, the first (Plate 27) for £50 from a Berlin-based dealer and the second (Plate 28) for £3 8s. 6d from the London-based

Plate 25
Kettle, or ewer, decorated in gold wires with design of scrolling *karakusa* and geometric, *shippō* and floral motifs. Unsigned. Nagoya, c.1860. Height (including handle) 15.2 cm. V&A: 894–1869.

Plate 26
Tiered food box (*jūbako*) decorated with floral and abstract motifs; the lid has a scene of cranes and pines on the legendary mountain-island *Hōrai*, a place of eternal youth and immortality. Unsigned. Nagoya, c.1860. Height 19.7 cm. V&A: 895–1869.

Plate 27
Dish decorated in brass wires on a ground of stylized floral and geometrical motifs with two dragons fighting for the sacred Buddhist pearl of wisdom. Unsigned. Nagoya, c.1865–70. Diameter 54.1 cm. V&A: 326–1872.

Plate 28
Dish decorated with a central roundel of a butterfly and flowers, perhaps dandelion (*tampopo*). Unsigned. Nagoya, c.1865–70. Diameter 24.7 cm. V&A: 595–1875.

East and West India Dock Company. Apart from their relative sizes, it is difficult to explain the wide disparity in the prices paid for these two pieces – although it is interesting, in this respect, that when Andō Jūbei visited the V&A in 1910 he pronounced the former to have been made by Kaji Sataro, son of Tsunekichi. What one can say with certainty is that neither dish can have been more than a few years old at the time of acquisition.

The next major group of cloisonné enamels to enter the V&A were part of a collection of '27 pieces of stoneware, enamels etc.' purchased from Siegfried Bing, the Paris-based entrepreneur and dealer.[37] Bing did particularly well from the V&A: 1,800 francs were paid, for example, for just this one unusual item (Plate 29), which is either a brazier (*hibachi*) or an incense-burner (*kōro*). There is some doubt as to the origins of the piece. The ground enamel is a very pale turquoise and the wires are of twisted or hammered silver, both suggestive of a non-Japanese, possibly Korean origin. On the other hand the decorative edges (*fukurin*) are distinctly Japanese. Could this simply be an early experimental piece of Japanese cloisonné?

In 1880 the V&A acquired several items from Christopher Dresser's company, Londos & Co. The two small unsigned vases (Plate 30) included in this group may, on

INTRODUCTION **31**

Plate 29
Incense-burner (*korō*) or firebox (*hibachi*) decorated with scrolling *karakusa*, cloud and bat motifs and a mythical bird, perhaps a type of *Hō-ō*. Unsigned. Nagoya, c.1865–70. Overall height 27.9 cm. V&A: 1121–1875.

Plate 30
Pair of vases decorated with stylized clouds, Japanese cranes, chrysanthemums and pine boughs. Unsigned, but attributable to Namikawa Yasuyuki. Kyoto, 1870–80. Height 8.6 cm. V&A: 360+a–1880, purchased from Londos & Co., Christopher Dresser's company.

Plate 31
Dish decorated with a central panel of a seated samurai in full armour surrounded by geometric diaper patterns, the back with butterflies and stylized flowers. Unsigned, but attributed to Seizaburō Gotō of Honchō-dōri, Yokohama. Diameter 30.5 cm. V&A: 237–1881.

stylistic grounds, be early examples of the work of Namikawa Yasuyuki. That they may be of Kyoto origin was first suggested by Hayashi Tadamasa (1853–1906) when he visited the V&A in 1886 to assess the Japanese collections. Hayashi had studied at what is now Tokyo University and in 1878 served as an interpreter at the Paris Exposition; he stayed on in Europe and became a significant dealer and advisor on Japanese art.

The first clearly identified piece of Japanese cloisonné enamel to have entered the V&A is a small dish (Plate 31), acquired in 1881, which Museum records state was made by Seizaburō Gotō of Honchō-dōri, Yokohama, another, although less important, centre of cloisonné production. The V&A did not, on this occasion, fall into the trap, as it had tended to do with earlier acquisitions, of classifying it as 'ancient Japanese'. By the 1890s the V&A was much more aware of the names of contemporary makers, though attributions continued to be a little vague. This rather elegant unsigned covered vase (Plate 32), for example, is

Plate 32
Lidded vase decorated with dragons, stylized mythical killer whales (*shachi*), a creature long associated with Nagoya, and stylized *Hō-ō* (phoenix). Unsigned. Nagoya, c.1890. Height 21.6 cm. V&A: 614–1894.

described as being the work of 'Nami-Kawa of Kioto' (*sic*), when in fact it was far more probably made in Nagoya.

In 1886 the V&A received the bequest of Frank Dixon. Included in the bequest were several interesting examples of Nagoya enamels, none of which could have been made very long before the Museum was given them (Plate 33). The bequest also included two small vases, which, judging from the style of wiring and their colour schemes, may be early works of Namikawa Yasuyuki (Plate 34). These vases are stylistically very similar to those illustrated at Plate 30. They were followed by further sporadic acquisitions. In 1901, for example, following the death of James Lord Bowes, the V&A acquired from the sale of his collection the bowl numbered 'Bowes Collection, Enamels No.1'. With its heavily applied semi-matt enamels and thick brass wire, the bowl shows all the indicators of an early example of Japanese cloisonné enamels. Curiously, the interior of the piece is very rough and appears to have been only partially polished (Plate 35).[38]

Two years later, in 1903, the V&A acquired as part of a gift from the London-based dealer John Sparkes its first signed piece by Namikawa Yasuyuki (see Plate 19). The Sparkes gift also included an elegant but unsigned vase (Plate 36), which Andō Jūbei, when he visited the V&A in 1910, claimed he had been responsible for making. Andō's visit to the V&A took place at the time of the Japan British Exhibition at White City in London, where the Andō Company had a stand. Museum records of the time show that the V&A rejected the offer that Jūbei made of ten contemporary works. These have yet to be positively identified, but we know that they included a vase with a 'wireless design of Mount Fuji' and several vases of 'raised enamel' (perhaps *moriage*). The Museum authorities justified their decision in the following straightforward terms: 'the board do not desire to purchase for this Museum the specimens of modern enamelling'.[39]

The V&A did, however, purchase other objects from Andō including a lacquered Buddhist figure and a cloisonné vessel. This piece was described as a 'covered vessel of early workmanship' (Plate 37) and was bought on the grounds of being 'an interesting example of the early Japanese attempts at enamel work on other than very small objects'. This

Plate 33
Vase decorated with a panel of a rustic scene, abstract geometric and floral patterns, large butterflies and the mythical *Hō-ō*. Unsigned. Nagoya, c.1870–80. Height 55.3 cm. V&A: 1271–1886, Dixon bequest.

Plate 34
Pair of vases decorated with butterflies and stylized chrysanthemum. Unsigned but attributable to Namikawa Yasuyuki. Kyoto, c.1870–80. Height 8.6 cm. V&A: 1274+a–1886, Dixon bequest.

Plate 35
Bowl decorated with four Chinese philosophers (one is just visible), in the interior a dragon, all on a ground of stylized clouds and an abstract floral motif. Unsigned. Nagoya, c.1865–70. Height 8.8 cm, diameter 19.1 cm. V&A: 680–1901, purchased from the sale of the Bowes collection.

Plate 36
Vase with silver wire decoration of wisteria emerging from stylized clouds. Unsigned, but attributed to Andō Jūbei. Nagoya, c.1895–1900. Height 30.8 cm. V&A: 265–1903.

unfortunate passing by of an opportunity to purchase contemporary works by Jūbei can be explained by the fact that by the beginning of the twentieth century the V&A had adopted a policy of acquiring only historical works of art and had stopped buying anything new.

The V&A's cloisonné collection has grown only modestly since the time of Andō's visit to London. A small group of pieces, which included a work by Namikawa Yasuyuki (Plate 38), was bequeathed to the V&A in 1969, but otherwise there have been few additions of significance. The hope is, however, that the V&A will be able to expand its holdings in this area and thereby give due recognition to an aspect of Japan's artistic legacy that has been the focus of increasing interest among museums and collectors since at least the early 1990s.

Plate 37
Lidded vessel decorated with thick brass wire chrysanthemum and small leaf-like shapes. Unsigned. Nagoya, c.1870–80. Height 19.4 cm, maximum width 22.3 cm. V&A: M.382–1911.

Plate 38
Tea-jar (*natsume*) with a mirror-black enamel ground covered with gold-wire decoration of summer flowers and scrolling *karakusa*. Signature of Namikawa Yasuyuki. Kyoto, c.1880–1900. Height 6.4 cm, diameter 5.4 cm. V&A: M.75–1969, Margary Gift.

Notes

1. Harada (1911), p.271.
2. For another opinion of the same object, see Suzuki (1979), p.91, and Suzuki (1993), p.73.
3. Harada (1911), p.276.
4. Alcock (1878), p.190.
5. Brinkley (1901), vol.VII, pp.375–6.
6. Salwey (1906), p.235.
7. Bowes (1884), pp.33–4.
8. Harada (1911), pp.278–81.
9. Illustrated in Suzuki (1993), p.34, no.77.
10. Seckel and Brinker (1970), pp.315–35.
11. Bowes (1895), p.81.
12. Brinkley (1901), vol.VII, pp.330–31.
13. Brinkley (1901), vol.VII, p.334.
14. Brinkley (1901), vol.VII, p.334.
15. *Shippō-chō Shippōyaki Art Village Inaugural Exhibition Catalogue* (2004), p.34.
16. Illustrated in Coben and Ferster (1982), pl.12.
17. Meiji no Takara (1994), p.22.
18. For another bowl of similar size and decorative palette, see Coben and Ferster (1982), pl.20.
19. Coben and Ferster (1982), p.31.
20. Coben and Ferster (1982), p.31.
21. Brinkley (1901), vol.VIII, p.297.
22. Harris (1994), p.111.
23. Harada (1911), p.278.
24. Meiji no Takara (1994), p.30.
25. For the Namikawa/Shibata debate, see Meiji no Takara (1994), no.33.
26. For a detailed analysis of Yasuyuki's career and oeuvre, see Meiji no Takara (1994), pp.28–38.
27. Kipling (1904), pp.387–9.
28. Salwey (1906), p.234.
29. Ponting (1910), pp.53–67.
30. Ponting (1910), p.59.
31. Ponting (1910), pp.65–7.
32. Impey and Fairley: Meiji no Takara (1994), p.40. Coben and Ferster (1982), p.133.
33. *Namikawa Sōsuke* (c.1896), pp.6–7.
34. For a panel of Mount Fuji by the Andō Company, see Earle (2002), no.176.
35. Harada (1911), pp.282–3.
36. See the catalogue entry on p.137 and Meiji no Takara (1994), pp.26–8.
37. V&A Nominal File, S. Bing.
38. This bowl is illustrated in Bowes (1884), p.41, pl.V.
39. V&A Nominal File, J Andō.

Signatures, makers' marks and inscriptions of objects in this collection are reproduced alongside the photograph of the object itself.

Edwin Davies Cloisonné Collection

38 JAPANESE CLOISONNÉ: THE SEVEN TREASURES

Vase
Unsigned; Nagoya style, possibly by Hayashi Kodenji
c.1890
Height 145 cm, width 50 cm

The copper body of this impressive vase has an applied plain copper rim and copper baseplate. The vase has an overall dark blue enamel ground and is decorated with birds (loosely based on a jay) perching on wisteria and chrysanthemums in copper and silver *yūsen*. Areas such as the petals, leaves, plant stems and birds' plumage are expertly shaded in pink, white and blue enamels within the cloisons to create an almost three-dimensional effect. Certain areas, particularly the petals, have highlights in *shōsen*. A small area under the rim is decorated in a *yūsen* diaper pattern of geometrical shapes. Cloisonné work on this scale was not uncommon at a time when Japanese artisans were keen to show their technical and artistic skills to the full, especially to the burgeoning Western market.

Pair of candlesticks in the shape of quail holding branches of plum blossom
Unsigned; Chinese
Qianlong period (1736–95)
Height 22.5 cm, width 11.5 cm

The enamelled quails take the form of traditional incense-burners (*kōro* in Japanese) with removable back-plates but without holes for the smoke to exit. The heavy copper bodies have thick brass *yūsen* wires enclosing areas decorated with black, red, green, yellow and blue enamels on a typical Chinese-style dark turquoise enamel ground. The bases, feet, legs, beaks and candle-holders are all of gilt bronze. The appearance and popularity of objects in pairs during the Qianlong period reflect the influence of the West in China. Artefacts of this kind were made for both domestic and export markets.

Vase
Unsigned; Nagoya style
c.1920
Height 30 cm, width 21 cm

The copper body of the vase has an applied silver rim and silver base-plate with the *jungin* mark. The pale blue enamel ground has an applied decoration of fantail and black telescope goldfish (*kuro-demekin*) swimming through pondweed. The pondweed and background are formed by shaded *musen* enamels and the fish are fashioned through the use of silver *yūsen* for the eyes with *ginbari*-style foil behind them. There is clear and translucent *tōmei-jippō* on parts of the fishes' bodies with some *shōsen* decoration for the tailfins. Highlighting of the body has been achieved by light hammering (*nanako*) of the copper surface. The counter-enamel is of a matt green colour. The subtly applied and graded colours of the ground give the impression of the watery depths from which the fish emerge. For a similarly decorated vase by Gonda Hirosuke, of c.1935, see Coben and Ferster, *Japanese Cloisonné* (1982), plate 156.

Pair of vases

Unsigned; Nagoya style, possibly by Hayashi Kodenji or Hayashi Kihyōe
1900–05
Height 45 cm, width 23 cm

The copper body of the vase has an applied silver rim and silver base-plate. The interior counter-enamel and inner base-plate are of a matt dark green to turquoise enamel. The underside of the lip has a decorative band of *shippō* motifs in white and turquoise *yūsen* enamels; above the foot-rim are 'cicada-wing' lappets with an abstract geometrical floral design. Both vases have an overall ground of dark blue enamel with *yūsen* decoration of butterflies (for the smaller butterflies a combination of copper, silver and gold wires) together with several varieties of large- and small-leaf chrysanthemum. There is some finely shaded enamel decoration, especially in the leaves of the chrysanthemum, which gives a natural three-dimensional effect.

Pair of vases

Nagoya; mark of Ogasawara Shūzō
c.1900–10
Height 12 cm, width 7.5 cm

The silver body of each vase has an applied silver-gilt rim and inner neck-ring together with a silver base-plate. The main body is decorated with carp and pondweed on a background that has been hammered all over (*nanako*). The fish and weed were also hammered prior to silver foil being applied to some areas. Graded transparent coloured enamels were applied to the ground and to parts of the fish. Some areas on the bodies of the carp have been left clear of coloured enamel so that the hammered, bright copper body can be seen through it. The vases have then been covered with a clear enamel finish. Placed side by side the two vases give the impression of fish meeting under a broad expanse of water. The silver-gilt inner base-plates carry the stamped two-character mark *Shūzō* within an oval ring. For a larger single vase by Ogasawara Shōzō with very similar decoration, see Coben and Ferster, *Japanese Cloisonné* (1982), plate 114; for a large vase by Hayashi Kodenji with similar decoration, see Barry Davies Oriental Art, *Japanese Enamels of the Golden Age* (1990), no.12; and for a piece by Ogasawara Takajirō acquired at the Exposition Universelle de Liège in 1905, see Kozyreff, *Tradition et transition* (1998), p.372.

Vase

Unsigned; probably Andō Company
c.1910
Height 30 cm, width 18 cm

The copper body has an applied silver rim and silver base-plate with the *jungin* mark. The inner counter-enamel is of a matt dark brown. The vase is decorated with three carp swimming through ripples rendered in *musen moriage* on a pale blue enamel ground. The carp are fashioned in a combination of silver *yūsen* and *shōsen* with some low-relief *moriage*. A layer of clear enamel has been applied over the areas of the fish that are under water to emphasize the head that emerges from the water and creates a large ripple. While there is a very similar vase by Gonda Hirosuke in the collection of the Shōsenkyō Cloisonné Museum in Kōfu (Shōsenkyō, Ropeway Cloisonné Art Museum, 1994, pp.20–21), most comparable known pieces can be positively attributed to the Andō Company. For a pair of vases attributed to Andō Jūbei, the left vase of which is almost identical to this piece, see Coben and Ferster, *Japanese Cloisonné* (1982), plate 124.

Three-legged bowl

Unsigned; Chinese
Kangxi period (1662–1722)
Height 6.6 cm, width 12.6 cm

The heavy copper body is decorated with gold (or possibly gilded brass) *yūsen* wires and there is gilt decoration to the rim, interior and feet. The tops of fixings visible inside the bowl indicate that the feet have been applied separately. The ground enamel is of the typical Chinese matt dark turquoise colour and decoration is of scrolling floral motifs (*karakusa*) and lotus flowers (or possibly the Buddhist *Hōsōge* flower) in red, green, white, pink and blue enamels. The bowl was probably intended for the burning of incense. While its enamelled base has a cast gilt-bronze plaque carrying the Xuande (1426–35) reign mark, the object is more likely to be of the Kangxi period (1662–1722). In pre-seventeenth-century China, cloisonné objects were used for the furnishing of temples and palaces: their colourful decoration was considered more appropriate for these settings than for the more restrained surroundings normally associated with a gentleman scholar. This was explained by Cao Zhao (or Cao Mingzhong) in 1388 in his *Gegu Yaolun* ('Guide to the Study of Antiquities'), in which he wrote of cloisonné as being suitable only for ladies' chambers. By the time of Emperor Xuande, however, cloisonné enamels had become prized at court. The Xuande period has always been considered the Golden Age of metalwork and some later Kangxi pieces were made under imperial command with a spurious Xuande mark.

Vase

Nagoya; mark of Ogasawara Shūzō
c.1910
Height 6.5 cm, width 13 cm

The copper body has an applied and recessed silver rim and silver base-plate. The counter-enamel is transparent. The ground is of a very dark blue transparent enamel over a *tōmei-jippō* design of a dragon flying over waves. The design has been executed by hammering the details of the dragon and waves from the outside, followed by overlaying with silver foil and the application of transparent enamel. The hammering marks are clearly visible through the clear enamel on the interior of the vase. The silver inner base-plate carries the stamped two-character mark *Shūzō* within an oval ring.

Two vases

Nagoya; mark of Hayashi Tanigorō
c.1912–26
Height 24 cm, width 12 cm

The copper body of each of these two vases has a separately applied silver rim and silver base-plate. Although not actually a pair, the vases are variations of the same design. Each is decorated with stylized birds, probably a type of wagtail, in gold *yūsen* with black, grey, white and yellow enamels on a dull green ground. The birds stand beside budding pine boughs rendered in shades of green and brown *yūsen* and *shōsen* enamels. The decorative theme of the vases is that of *shōchikubai* ('Three Friends of Winter' – plum blossom, pine and bamboo): the pine branches are complemented by plum blossoms just under the rim and stylized bamboo leaves above and around the base. The Three Friends of Winter have long been regarded as symbols of hope and good fortune: bamboo and pine stay green throughout the winter, while the plum is the first tree to flower in the spring, thereby signalling the coming end of winter. The inner bases of the vases contain a seal with the two-character mark *Hayashi Tani*[*gorō*] in gold *yūsen* filled with black enamel.

Vase

Unsigned; Nagoya style, possibly Andō Company
c.1912–26
Height 13 cm, width 22 cm

The copper body of this small elegant vase has a separately applied silver rim and silver baseplate with the *jungin* mark. The pale green enamel ground has silver *yūsen* decoration of mythical *Hō-ō* (phoenix; here resembling peacocks) among cloud-like *karakusa* floral scrolling interspersed with lotus and *Hōsōge* flowers with petals highlighted with shaded enamels. There are also fine stylized silver *yūsen* cloud whorls around both the rim and the base. The overall subject matter here is Buddhist in origin: the Hō-ō is originally found in Chinese art and is an auspicious, imaginary creature. In Buddhism, they are symbols of the southern direction and one of the guardian animals of the four directions. The *karakusa* (literally 'Chinese grass') motif is often found together with lotuses (a subject also frequently found in Buddhist art) and other flowers.

Vase

Kyoto; mark of the Inaba Company

1912–26

Height 6.5 cm, width 7.5 cm

The copper body has an applied silver rim and the silver base-plate has been stamped with the *jungin* mark. The vase is decorated with a gold *yūsen* coloured enamel design of chrysanthemum, which have slightly shaded enamel details on their petals. The leaves are of dark green enamel with some shading; the wires here are almost hidden, although whether by design or by accident is unclear. The body has been finished with a matt olive-brown enamel ground. The counter-enamel is of a similar colour to the body and the inner base has the rather poorly applied silver *yūsen* mark of the Inaba Company of Kyoto.

Two vases

Unsigned; probably Nagoya
c.1920–40
Height 9 cm, width 4.5 cm

Each of these two unmatched but similar-looking vases has a silver rim; the base-plate on the left-hand vase is silver and that of the right-hand one is silver-gilt. The copper body of each has been hammered (*nanako*) and the ground covered with silver foil (*ginbari*) prior to an overall application of light turquoise enamel. The decoration is of summer (left) and autumn (right) flowers and grasses in polychrome silver *yūsen* enamel: the flowers include convolvulus, gentian, various grasses, chrysanthemum and bell-flower. This style of enamelling and decoration is often associated with Kumeno Teitarō. For similar pieces signed by Kumeno, see Coben and Ferster, *Japanese Cloisonné* (1982), plate 110, and Fairley, *Japanese Enamels of the Meiji Era* (1998), nos 35 and 36.

Pair of four-footed incense-burners (kōro)

Unsigned; Chinese, Qianlong period (1736–95), or Japanese, c.1900–20

Height 11 cm, width 10 cm

The heavy cast-bronze body of each of these vessels is decorated with gilded brass (or gold) wire and has a separately applied rim and twisted wire handles, all of gilt bronze. The bright turquoise enamel ground is decorated with red, green, yellow, white, pink and blue enamels. The shoulders bear abstract geometric patterns and the body scrolling vine motif and abstract flowers (possibly lotus and Buddhist *Hōsōge* flowers). The ground enamel is of a brighter hue than is usually found on Chinese cloisonné enamels: it is reminiscent of the type of Japanese enamelware known as *Hōgyoku Shippō* ('Jewel Enamels'), which was produced in Japan, in imitation of earlier Chinese models, from about 1897 until 1923. *Hōgyoku Shippō* were made in Kobe by Kaji Satarō and were privately commissioned by the industrialist and shipping magnate Kawasaki Shōzō, who had a huge personal collection of Chinese cloisonné. *Hōgyoku Shippō* were never intended for the open market, being used principally as personal gifts to clients of the Kawasaki Ship Building Company, shrines, temples and the imperial family. For comparable objects, see Nagoya City Museum, *Hōgyoku Shippō* (2000), nos 17 and 18.

Two vases

Unsigned; Nagoya
1912–26
Height 13 cm, width 13 cm (left); height 15.5 cm, width 8 cm (right)

Each of these unsigned *shōtai-jippō* vases has an applied chrome-plated rim and baseplate. Both vases have an overall silver *yūsen* design of peony, bell-flower, rose, hibiscus, convolvulus, gentian and chrysanthemum in various colours of shaded enamels on a translucent enamel ground of pale green. The enamels have been applied thickly to allow for the dissolving of the copper body. There has been much discussion as to the dating of the first production of *shōtai-jippō* in Japan: dates from 1900 to 1910 have been given, while the technique is thought to have been perfected by Kawade Shibatarō on behalf of the Andō Company. Although these two pieces have the thicker and heavier enamels usually associated with early examples of *shōtai-jippō*, their chrome-plated rims suggest a later date.

Vase

Nagoya; mark of the Andō Company
c.1900
Height 16.5 cm, width 6 cm

The vase has a standard copper body with an applied silver rim and silver base-plate; the visible interior is silver-gilt. The body of the vase has been hammered to give a *nanako* ground and the lower part decorated with a hammered and engraved design of a dragon emerging from wild waves (the dragon in Japan is a water creature associated with both the sea and clouds). The vase is covered with a transparent red enamel in the technique known as *akasuke*. This type of enamelling is believed to have been invented around 1880 by Ōta Jinnoei and Honda Yosaburō (Coben and Ferster, *Japanese Cloisonné*, 1982, p.132). The silver base-plate carries the stamped mark of the Andō Company. This simple cross-shaped mark is based on the Japanese character for the number 10. Pronounced *jū*, it is a homophone for the more intricate character used for the first part of the name of Jūbei, the founder of the Andō Company. For a comparable piece by Hayakawa Komejirō, see also Coben and Ferster, *Japanese Cloisonné*, plate 106.

Two vases

Unsigned; Nagoya
c.1912–26
Height 13 cm, width 8.5 cm (left);
height 9 cm, width 8 cm (right)

The left-hand vase has an applied silver rim and base-plate; the right-hand vase has a chrome-plated rim and base-plate, both of which are slightly tarnished. There are small circular and semicircular cloisons around the base-plates and rims, those around the rims resembling bubbles rising to the surface. Both vases have silver *yūsen* designs of fringe-tail goldfish (perhaps of the type known as *ryūkin*) and pondweed in various colours of shaded enamel on a translucent *shōtai-jippō* ground of pale blue-green. The thick and heavy enamel ground on both vases creates the effect of looking at fish through water.

Vase

Nagoya; mark of the Andō Company
1912–26
Height 25 cm, width 10 cm

The vase, of typical Chinese shape, comprises a copper body with applied silver rim and base-plate. It is decorated in a combination of silver *yūsen*, *shōsen* and *musen* enamels with a mountainous landscape. The scene includes a temple partly hidden by a foreground of pine trees and rocks. Around the rocks and trees is a raging torrent with mountain peaks rising out of the mist in the background. The subtle decoration is in the style of a Chinese landscape painting, perhaps following the 'blue-green' tradition of artists such as Qiu Ying (1494–1552), who in turn influenced Japanese painters such as Tani Bunchō (1763–1841). Bunchō is known for his work in the *Nanga* (literally 'Southern Painting') Chinese style. The design has been executed in varying shades of blue-, green- and red-shaded enamels on a yellow-green enamel ground. The base contains the mark of the Andō Company (in a rather loose style) in silver *yūsen*.

The vase also reproduces a type of Chinese porcelain known in English as 'eggshell' and in Chinese as *qianjiang*, which became widespread during the late nineteenth and early twentieth centuries. This vase is evidence that there was a rapid transfer of styles and influences between China and Japan at that time. It has been suggested that it was made by Mr Okumura, who worked for the Andō Company (private communication with Inaba Katsumi). There is a pair of similarly decorated vases by Gonda Hirosuke in the collection of the Shōsenkyō Cloisonné Museum in Kofu (Shōsenkyō Ropeway Cloisonné Art Museum, Kōfu, exhibition catalogue, 1994, pp.18–19).

Vase

Nagoya; mark of Murase Jinsaburō
1900–10
Height 12 cm, width 6 cm

The silver-bodied vase, with a separately applied silver rim and silver base-plate, is decorated with a fantailed goldfish emerging though rippled water under hanging wisteria. The ground of the vase has been hammered to give a *nanako* effect, over which light-blue enamel has been applied. The fish and ripples have been hammered from the inside of the vase and then chased. The decoration of the fish has been carried out in a combination of *tsuiki* and *tōmei-jippō*, and there are small areas of chased copper visible on parts of the fish. The wisteria is rendered in polychrome silver *yūsen*. The whole vase has a final overall coating of clear enamel. There are two marks on the base: in Roman script the word 'SILVER' and in Japanese phonetic script the name *Murase* (*Jinsaburō*). While Coben and Ferster (*Japanese Cloisonné;* 1982) state that the word 'Silver' does not appear on cloisonné enamels until after 1945, there is little doubt that this piece dates from an earlier period.

Vase

Nagoya; probably Andō Company
c.1912–26
Height 37 cm, width 19 cm

The vase has a copper body with an applied copper rim and base-plate, both of which may once have been patinated to a *shakudō* finish. The flowering plant, most likely *Katsura Japonica* (known in Japanese as *binan-kazura* or *saneka*), has been rendered in an almost impressionistic way in *musen* enamels with subtly shaded polychrome enamels on the flowers, leaves and stems. However, there is a naturalistic quality in the almost three-dimensional representation of some of the leaves, particularly the undersides, and the shading on the stems, a quality enhanced by the fact that some leaves show signs of decay and insect damage. The ground enamel is a pale blue-grey. For an imperial presentation vase by Andō with a more naturalistic impression of this same plant, see Meiji no Takara, *Treasures of Imperial Japan* (1994), no.54, and Earle, *Splendors of Imperial Japan* (2002), no.310.

Pair of vases

Nagoya; mark of the Andō Company
c.1912–26
Height 31 cm, width 16 cm

The copper bodies of both vases have applied silver rims and base-plates carrying the stamped *jungin* mark; the counter-enamel is of a dark olive-brown colour. The left-hand vase depicts an angry-looking tufted male bird perched on a tree. The enamels used to depict the bird are a combination of silver *yūsen* and *shōsen*, with the bird's plumage softly defined in subtle shades of polychrome enamels. The tree is probably of the *Moraceae* family (which includes both mulberry, *Morus alba,* and the fig, *Ficus L.*), the fruits of which have gone to seed; the same tree is also to be found on the companion vase. The leaves of both trees are executed in silver *yūsen* and *shōsen*, and the shaded green enamels are exquisitely applied in a very painterly fashion. The right-hand vase has a pair of similar birds (male and female) as the left-hand vase and they are executed in the same enamels. The subtle use of enamel on the right-hand vase is particularly noticeable on the foreground trunk, while the rear trunk has been executed in paler shades of greys to create the illusion of space and distance. The grounds of the vases are of pale grey-blue enamels. The interiors of the bases bear the silver *yūsen* mark of the Andō Company; the associated wooden stands for the vases (not shown) have original Andō Company labels.

The exotic birds on these vases have not been positively identified and are likely to be a 'hypothetical species', perhaps based on the Japanese waxwing (*Bombycilla japonica*) or the Asian paradise flycatcher (*Tersiphone paradise*). For a similar bird on a painted and cut-velvet hanging scroll, see Earle, *Japanese Art and Design* (1986), plate 184; and on another cloisonné vase, see Meiji no Takara, *Treasures of Imperial Japan* (1994), no.52.

Vase

Nagoya; mark of Hayashi Kodenji
c.1880–90
Height 25 cm, width 12 cm

The copper body of the vase has an applied silver rim and base-plate; the inner neck and interior of the base-plate are both silver-gilt. The vase has a dark blue-black enamel ground with a silver *yūsen* design of exotic long-tailed butterflies, the bodies of which have some *shōsen* to define the curves of the body. The vase is a tour-de-force in which Hayashi has captured the feel of butterflies mingling together while retaining a sense of space around them. A wide range of opaque enamels has been used in combination with a transparent green-speckled enamel (similar to *chakinseki*), for example on the upper butterfly. The interior of the base-plate is of silver-gilt and has the engraved six-character mark *Aichi Hayashi Kodenji* within a rectangular cartouche. There is an altogether far more naturalistic feeling to the butterflies portrayed on this piece than those, for example, on the well-known gourd-shaped vase of 1893 by Namikawa Yasuyuki in the collection of the Tokyo National Museum. For Namikawa's vase, see *Arts of East and West from World Expositions* (2004), p.128, I-349.

Bowl

Unsigned; Chinese, early 19th century, or Japanese, c. 1850

Height 8.5 cm, width 14 cm

The heavy copper body with a separately applied gilt rim and base-plate is decorated in brass wires with an equally spaced design of four horses (one each in predominantly red, blue, white and yellowish-brown enamels), together with abstract Buddhist flaming-jewel motifs. The rim is decorated with a panel of abstract cloud motifs and the turquoise enamel ground is covered with wires forming a wave pattern. The use of a large number of wires on the ground is characteristic of techniques employed by early nineteenth-century Japanese cloisonné makers, who also closely copied Chinese models. One may speculate that this misshapen piece, with its simple design and colour scheme, could be either Chinese or an early example of Japanese cloisonné enamels by an artist such as Kaji Tsunekichi.

Bowl

Unsigned; Nagoya
1926–90
Height 6.5 cm, width at rim 12.5 cm

This *shōtai-jippō* bowl has an applied chrome-plated rim and foot-edges. It is decorated with a simple silver *yūsen* and *shōsen* design of plum blossom (*ume no hana*) in yellow and translucent enamels on a translucent enamel ground of pale green. Under the rim is a small band of semicircular silver *yūsen* geometric motifs. As with other examples of *shōtai-jippō* bowls, the three small feet have been applied separately. Very similar pieces were still being produced in Nagoya and sold through the Inaba Company of Kyoto until the late 1990s (and illustrated in brochures of that period).

Vase

Unsigned; Nagoya

1912–26

Height 7.9 cm, width at rim 13.7 cm

This elegant *shōtai-jippō* bowl has an applied chrome-plated rim and foot-edges. It is decorated with a silver *yūsen* design of peony, convolvulus, rose, gentian and chrysanthemum in polychrome shaded enamels on a translucent enamel ground of pale green. Under the rim is a delicate trailing pattern of green leaves in silver *yūsen* enamels. The bowl has a relatively light body, to which three small feet have been attached. Similar pieces were still being produced in Nagoya and sold through the Inaba Company of Kyoto until the late 1990s. For an almost identical bowl by Katō Hideo, see Suzuki, 'Shippō' (1993), p.95, illus.13.

Two vases

Unsigned; Nagoya
c.1920–40
Height 13 cm, width 8.5 cm (left);
height 13 cm, width 9 cm (right)

These *shōtai-jippō* vases have applied chrome-plated rims and base-plates. The left-hand vase has a design of cherry blossom (*sakura*), symbolic of spring, in silver *yūsen* and *shōsen* enamels. The centres of the blossoms are translucent yellow enamel while the petals are translucent white. The ground is of opaque pink enamel. There is a small band of circular silver *yūsen* shapes under the rim, and a small band of semicircular silver *yūsen* geometric shapes above the base. The right-hand vase has a design of plum blossom (*ume no hana*), symbolic of the end of winter, in silver *yūsen* and *shōsen* enamels identical in colour and technique to the cherry blossom on the left-hand vase. The ground on this piece is of an opaque mottled blue enamel. There is a similar silver *yūsen* pattern around the rim. Both vessels are quite heavy for their size because the enamels have been applied thickly. Placed together, the two vases poetically evoke the changing of the seasons.

Two vases
Unsigned; Nagoya
c.1926–89
Height 9 cm, width 8 cm (left);
height 9 cm, width 8 cm (right)

These two *shōtai-jippō* vases have applied chrome-plated rims and base-plates. The left-hand vase has a silver *yūsen* and *shōsen* design of maple leaves (*momiji*) in shaded red and green enamels on a translucent green enamel ground. The right-hand vase has a silver *yūsen* and *shōsen* design of cherry blossom (*sakura*) in shades of pink, yellow and green enamels on a translucent pink enamel ground. Both vases have silver *yūsen* geometric patterns around their rims and bases. As a pair, they bring to mind the changing of the seasons, *momiji* and *sakura* being the classic signifiers, respectively, of autumn and spring. Very similar pieces were still being produced in Nagoya and sold through the Inaba Company of Kyoto until the late 1990s (they are illustrated in brochures of that period).

Vase

Nagoya; mark and signature of Hayashi Kodenji
c.1890
Height 9.5 cm, width 6.5 cm

The copper-bodied vase has an applied silver-gilt rim and inner neck-ring; the silver base-plate has a silver-gilt interior. The vase has a *nanako* ground, its lower part being decorated with a hammered and engraved design of a pair of carp emerging from pondweed into overhanging wisteria. The vase has been covered with transparent red enamel in the technique known as *akasuke*, which is believed to have been invented around 1880 by Ōta Jinnoei and Honda Yosaburō. The inner base-plate carries the mark and engraved five-character signature *Nagoya Hayashi Ko[denji]*.

Two vases

Unsigned, Nagoya
c.1920–40
Height 12 cm, width 8 cm

These two *shōtai-jippō* vases have applied silver-gilt rims and base-plates. They both depict the view of the Yasaka Pagoda seen from the Kiyomizu Temple (*Kiyomizudera*). This is one of the most famous views in Kyoto and the presence of the geisha, for which Kyoto is also renowned, at cherry-blossom viewing time (*hanami*) adds to the poetry of the scene. The theme of cherry blossom is echoed in the kimono worn by the two geisha, particularly the one on the left. The sense of romance is enhanced by the stylized clouds and pine trees in the distance. Both vases are decorated with silver *yūsen* and *shōsen* shaded enamels on a translucent green enamel ground, and both have silver *yūsen* geometric patterns around their rims and base-plates.

These splendidly evocative pieces of cloisonné could have been made for either the domestic or the tourist market, since the subject matter would have been popular with both. It has been suggested that they were made by Katō Toichi, who once worked for the Andō Company of Nagoya (personal communication from Inaba Katsumi).

Vase
Unsigned; Nagoya
c.1912–26
Height 15 cm, width 13 cm

The *shōtai-jippō* vase has an applied chrome-plated rim and base-plate. It is decorated with silver *yūsen* chrysanthemums in various shades of green and yellow enamels on a graduated translucent enamel ground of turquoise-green. The shoulder of the vase has an interesting abstract border of purple pendent chrysanthemum petals. There are silver *yūsen* geometric patterns around the rim and base-plate.

Vase

Unsigned; Nagoya
c.1960–90
Height 13 cm, width 9 cm

The *shōtai-jippō* vase has an applied chrome-plated rim and base-plate. It is decorated with a silver *yūsen* design of peony, gentian, convolvulus and chrysanthemum in varying shades of lightly shaded translucent green-blue enamels on a similarly toned translucent green enamel ground. There are silver *yūsen* geometric patterns around both the rim and the base. Very similar pieces were still being produced in Nagoya and sold through the Inaba Company of Kyoto until the late 1990s (and illustrated in brochures of that period).

Dish

Tokyo; seal of Namikawa Sōsuke
c.1895
Height 24 cm, width 30 cm

The copper body of the dish, whose shape is reminiscent of the Japanese *uchiwa* fan, has an applied gilt-copper rim. The design of the birds is in a combination of gold and silver *yūsen* and *shōsen* enamels. The birds are depicted in shades of black, white and grey enamels to give the effect of an ink painting on a greyish-brown graduated enamel ground. The back of the dish has the *Sakigake* seal of Namikawa Sōsuke in silver *yūsen* and the ground is covered with gold *yūsen* petals of plum blossom in shades of brown on a matt dark brown enamel. Although Sōsuke had demonstrated in 1889 that he could reproduce painterly designs totally without wires, he continued to produce *shippō* reproductions of paintings with wires to emphasize the design. There is a dish with an identical design in the collection of the Ashmolean Museum, Oxford, the only difference being that the back is decorated with formal motifs in coloured enamels and Sōsuke's seal is on red enamel. Other examples of similar dishes are illustrated in Fairley, (1998), no.66, and Impey and Fairley, (1991), no.22.

The design of the pigeons is after an original by Watanabe Seitei, whose signature and seal appear on the front of this dish. Born Yoshikawa Yoshimata and a student of the painter Kikuchi Yōsai, he later took the art name Watanabe Seitei. He also worked as a ceramics designer and an industrial draughtsman. In 1878 one of his paintings was accepted into the Paris Exposition, where it won a silver medal. He was best known for his paintings of birds and flowers, *kachōga* in Japanese. Around 1890 Seitei began designing woodblock prints and in 1891 completed his first three-volume album of bird and flower prints, *Seitei Kachō Gafu*.

Pair of vases

Nagoya; seal of Ōta Jinnoei

c.1880–85

Height 12.5 cm, width 5.5 cm

The copper bodies have applied silver rims and base-plates, and the inner neck-rings are of silver-gilt. There are small circular geometric patterns in red enamel around the rims and base. The decoration is of two tethered hawks on curtained rails in gold *yūsen* enamels. There is some shaded enamelling on the wing-feather tips and to the curtain, which is decorated with a scrolling flower design, and there is a wood-grain effect to the perches. The theme of hawks and other birds of prey was frequently associated with the samurai class and was popular in Japanese art. For example, there is a famous set of 12 bronze hawks on perches that was exhibited at the World's Columbian Exposition of 1893 in Chicago by the great metalworker Suzuki Chōkichi. The bottoms of the vases are stamped with the two-character seal *Ōta* (Jinnoei) within a tripod incense-burner (*kōro*) cartouche.

Box

Nagoya; mark of Kawade Shibatarō
c.1900–12
Height 5 cm, width 12 cm

This small elegant box has applied rims of either blackened silver or *shakudō*, and the copper body is decorated in gold *yūsen* enamels with a flower arrangement representing the four seasons (narcissus, peony, plum, chrysanthemum and grapes on a vine) in a woven basket. Areas of the leaves, petals and grapes are rendered in subtle and naturalistic shaded enamels on a pale grey enamel ground. The use of space is typically Japanese, as is the way in which sections of the grapevine and plum blossom continue from the lid across the rim and onto the main body. The lid has a gold *yūsen* seal with the two characters *Kawade* (Shibatarō) in a red enamel double gourd. There is some uncertainty about the nature of the material used on the rims. *Shakudō* is an alloy of copper with a small percentage of gold that can be patinated to a blue-black colour. However, a similar finish can be achieved by smoking silver with sulphur sticks to produce a silver-sulphide layer. The latter process, which is cheaper and quicker, was frequently used by cloisonné makers and can be extremely difficult to distinguish from *shakudō*.

Vase

Nagoya; mark of Hayashi Kodenji
c.1880–85
Height 15 cm, width 7 cm

The copper body has an applied silver rim and silver base-plate; the neck has a silver liner that is held in place by three small silver plugs. The vase has silver *yūsen* enamel decoration of chrysanthemum and other flowers and a bird (perhaps a type of warbler) perching on a branch of plum blossom. The back of the vase bears a flock of four similar birds in flight. The neck rim and foot-rim are decorated with silver *yūsen* enamel blossoms and small cloud-scrolls; the neck has a band of cicada-wing lappets; the shoulders and the area above the foot-rim are decorated with small chrysanthemums within stylized geometric panels. The whole design is executed on the very dark blue enamel ground typically associated with Hayashi Kodenji, whose stamped mark is carried on the gilt interior of the base.

Two vases

Kyoto; mark of Namikawa Yasuyuki
c.1900–10
Height 23 cm, width 8.5 cm

The copper bodies of these elegant vases, which may be part of a set representing the four seasons, have applied rims of blackened silver or, more probably, *shakudō,* and silver-gilt interior neck-rings and base-plates. The left-hand vase represents winter and has a gold *yūsen* enamelled design of branches of plum blossom with a bird hovering nearby. The right-hand vase has an autumnal scene with gold *yūsen* enamelled maple leaves, on the upper branches of which perches a bird similar to that depicted in the winter scene. Some leaves still retain their green summer hues to show the changing of the season. Both vases have the mirror-black enamel ground typically associated with Namikawa Yasuyuki. Each vase has a small band of geometric floral patterning, possibly bamboo leaves, just above the base-plate. The silver inner base-plates of both vases bear the stamped four-character mark *Kyoto Namikawa*.

The birds shown on the vases most closely resemble the Ashy Minivet, a common summer visitor to Japan. For vases of similar shape and with comparable decoration, see Earle, *Splendors of Imperial Japan* (2002), no.205; Meiji no Takara, *Treasures of Imperial Japan* (1994), no.23; Barry Davies Oriental Art, *Japanese Enamels of the Golden Age* (1990), no.10; Coben and Ferster, *Japanese Cloisonné* (1982), plate 92 (for another version of Autumn); Suzuki, *Nihon no Shippō* (1979), no.179 (for another design of a similar bird on a maple tree); Impey and Fairley, *The Dragon King of the Sea* (1991), no.19 (for another similar vase depicting Spring).

Vase

Nagoya; mark of the Andō Company
1912–26
Height 36 cm, width 19 cm

The copper body of the vase has a rolled lip with an applied blackened silver rim and base-plate. There is a silver *yūsen* and *shōsen* enamel design of Chinese spinach (*Amaranthus tricolour*; *Hageitō* in Japanese), a plant grown specifically for its decorative variegated foliage. The subtle variations in the colour of the leaves have been recreated by the careful use of hues of red, green and yellow enamels. The almost three-dimensional quality of the leaves is testament to the remarkable technical skills of the enameller. The vase has a pale grey-green enamel and the base-plate carries the silver *yūsen* mark of the Andō Company on a dark brown enamel base; this colour has also been used for the counter-enamel. For a pair of vases (with Imperial Crests) by the Andō Company, which are decorated with a similar plant, see Meiji no Takara, *Treasures of Imperial Japan* (1994), no.53, and Harris, *Japanese Imperial Craftsmen* (1994), no. 99.

Vase

Nagoya; mark of the Andō Company
c.1920–40
Height 18 cm, width 19 cm

The copper body of the vase has an applied silver rim and a silver base-plate with the *jungin* mark. The matt brown ground is decorated with a stylized silver *yūsen* and *moriage* arrangement of scrolling thistles and leaves in shades of brown, purple and white enamel. The interior has a counter-enamel of matt green, which is also applied to the interior of the base-plate. This has been inlaid with the gold *yūsen* mark of the Andō Company.

Andō cloisonné is often extremely difficult to date, compounded by the fact that the Company's records are sparse. The style of the decoration, which has a rather Art Deco feeling to it, suggests a date from the period 1920–40. However, since this style of decoration continued to be used until at least the 1960s, a later date cannot be ruled out.

Vase

Nagoya; mark of the Andō Company

c.1920–50

Height 25.5 cm, width 16 cm

The vase has a typical copper body with an applied silver rim and silver base-plate with the *jungin* mark. The olive-brown ground is decorated with a silver *yūsen moriage* and shaded design of pale olive-brown consisting of an upper band of stylized birds and a central band of 'cicada-wing' lappets containing stylized dragons. The interior counter-enamel is of a shiny, speckled dark brown, as is the inner base-plate, which bears the gold *yūsen* mark of the Andō Company.

The vase follows the shape and decorative style of an ancient Chinese bronze *Hu* of the Han dynasty (221 BC–AD 220). It is particularly interesting for the mixture of styles and techniques it uses and for its reference to ancient Chinese bronzes. This re-creation of an ancient bronze in cloisonné enamels is in keeping with Japan's long tradition of reproducing objects in alternative media. The associated box for this piece has an inscription describing the decoration as a 'male dragon' and carries the signature and seal of the Andō Company. For a comparable piece by Hayashi Tanigorō, dated c.1912–17 and in the collection of the Andō Company, see Coben and Ferster, *Japanese Cloisonné* (1982), plate 130.

Dish

Nagoya; mark of Hayashi Kodenji
c.1912–26
Height 6.5 cm, width 22.5 cm

The dish has a copper body with an applied silver rim and silver base-plate. There is a central silver *yūsen* enamel design of a mythical *Hō-ō* (phoenix) in shades of green, blue, red and white enamels. The *Hō-ō* is surrounded by a stylized floral and leaf pattern. The sides of the dish are decorated with abstract *yūsen* geometric patterning within two narrow white enamel bands. The ground of the dish is a dull green enamel colour. The inner base-plate has the mark of the Inaba Cloisonné Company, the third-generation head of which has proposed a date of 1910–20 (private communication with Mr Inaba Katsumi).

Fruit dish

Nagoya; mark of the Andō Company
c.1930–50
Height 13 cm, width 44 cm

This unusually shaped vessel has a copper body with an applied gilded rim and foot-edges. It is decorated with geometrical shapes delineated by gilded copper *yūsen* wires, which divide the yellow enamel ground into grid-like sections. The central side panels have been cast or hammered into curves; the wires here are largely invisible under heavily applied alternating bands of blue, white and dark orange enamel, areas of which have been highlighted in gold. The interior ground is a combination of thickly applied purple and turquoise enamels, with gilded vertical wiring. The inside of the dark brown enamelled base bears the gilt-copper *yūsen* mark of the Andō Company. The vessel has a strongly Art Deco feel and reflects the craze for Egyptian-inspired design that followed the discovery of Tutanhkamen's tomb in 1922. An inscription on the associated box for this vessel describes it as being for the presentation of fruit and carries the signature and faded red seal [*Andō*] *Jūbei*.

Vase

Nagoya; mark of Hayashi Kodenji
c.1880–90
Height 12.5 cm, width 7.5 cm

The copper body of the vase has an applied silver rim, a silver-gilt inner neck-ring and a silver base-plate, the interior of which is also silver-gilt. The pale grey enamel ground is decorated with a silver *yūsen* design of exotic butterflies. The butterflies' bodies have been skilfully delineated with different thicknesses of silver *yūsen* and areas of *shōsen*. The polychrome enamels of the wings have been applied in extraordinarily fine detail and there are two small 'eyes' in *chakinseki* on the upper butterfly. The inner base-plate is silver-gilt and carries the engraved four-character mark *Aichi Hayashi Ko[denji]* within a circular area.

Vase

Unsigned; Nagoya style, possibly Hayashi Kodenji
c.1900
Height 31.5 cm, width 19 cm

The copper body has a separately applied silver rim and a silver base-plate with the *jungin* mark. The silver *yūsen* and *shōsen* decoration depicts two exotic long-tailed birds in a clump of bamboo and flowering shrubs. Some areas, notably the tips of the leaves, have been rendered in softly shaded enamels. Both the rim and foot-ring are decorated in silver *yūsen* with bands of cicada-wing lappet and *shippō* motifs. The design is set against a rich blue enamel ground of the kind generally associated with the Nagoya School, and Hayashi Kodenji in particular. The counter-enamel is of a similar shade of blue, although it is not so highly polished. The unidentified birds are likely to be an imaginary species based on the Asian paradise flycatcher (*Tersiphone paradise*) or the blue magpie (*Urocissa sp.*).

Vase

Nagoya; mark of the Andō Company
c.1900–10
Height 24.5 cm, width 11 cm

The copper body has an applied silver rim, a silver-gilt inner neck-ring, a silver base-plate and a graduated peach-coloured ground. The design is of a Japanese marsh plant of the type commonly known as Arrowhead (probably *Sagittaria aginashi*), which is found in wet areas such as bogs, ponds and riverbanks. The distinctive triple spear-shaped leaves and small white flowers have been rendered in a combination of silver *yūsen*, *shōsen* and *musen* enamels. The shaded green leaves have an almost three-dimensional feeling to them, while the flowers are softly defined in shaded *musen* enamels. The twisting of the leaves adds to the naturalistic feeling of the design. The mark of the Andō Company in silver *yūsen* and white enamel has been applied to the dark brown enamel interior of the base plate.

Vase

Nagoya; mark of the Andō Company
c.1912–26
Height 25.5 cm, width 24 cm

The copper body has an applied silver rim and silver base-plate with the *jungin* mark. The blue enamel ground is covered with a design of abstract geometric scrolling flowers in silver *yūsen* and *shōsen*. The flowers, possibly based on a form of tree peony, and leaves are executed in subtle shades of blue that complement the ground colour. The counter-enamel is a dark matt-brown colour, as is the interior of the foot, which has the silver *yūsen* mark of the Andō Company. Stylistically, and according to the Andō Company archives, the vase is likely to date from the Taishō period (1912–26).

Vase

Unsigned; Nagoya style, possibly by Hayashi Kodenji
c.1895–1900
Height 47 cm, width 31 cm

The copper body has an applied silver rim and silver base-plate. The dark blue ground is decorated with silver *yūsen* chrysanthemums and male and female songbirds (possibly a type of finch) on a rock by a swirling stream. There is some superb shaded enamelling, quite painterly in its execution, especially on the flowers, leaves and rocks, but also used for details of the birds themselves. A strong sense of perspective is created by the arrangement of the rocks and water on the left of the vase: this is emphasized by the way in which the birds at the top left sweep in from above. The upper neck and foot of the vase are decorated with a band of silver *yūsen* geometric cicada-wing lappets in subdued shades of brown and cream enamels highlighted in red, blue and yellow. While this vase can be safely described as Nagoya style, there are similarly decorated vases in the collection of the Inaba family of Kyoto, for whose manufacture they may have been responsible.

Vase

Nagoya, mark of the Andō Company
c.1920–50
Height 30 cm, width 14.5 cm

The copper body has an applied silver rim and silver base-plate. It has a semi-matt enamel ground of purple-brown decorated with a single peony blossom on a stem, which has been executed in brass *yūsen* enamels. The petals of the blossom are in shaded white and purple *moriage*, while the leaves are flush with the surface of the vase. This combination of raised petals and flat leaves gives a sense of depth to the composition. The counter-enamel is of matt dark blue enamel, as is the interior of the foot, which has the silver *yūsen* mark of the Andō Company. Stylistically, and according to the Andō Company archivist (private communication from Mr Yoshida), the vase is likely to have been produced during the Taishō period (1912–26). It is known, however, that this design continued to be produced for some years after the Second World War, hence the date span given above.

Vase

Nagoya; probably Andō Company
c.1912–26
Height 24.5 cm, width 11.5 cm

The copper body has what, unusually, appears to be an applied gold rim and gold base-plate. The brown ground is decorated in silver *yūsen* and *moriage* enamels with a single tree peony blossom with buds on a stem. The blossom and buds are depicted in shaded *moriage* white and pink enamels; the foliage and stem are executed in the same technique, with the leaves having a rich green shading. The counter-enamel and inner foot are of a dull matt cream colour. The combination of relief decoration and subtly and expertly applied enamels together with careful use of space creates an elegant composition. The vase, which dates to the Taishō period (1912–26), is unsigned but was recognized by the Andō Company as probably being one of their pieces (private communication from Mr Yoshida).

Vase

Nagoya; mark of the Andō Company
c.1912–26
Height 31 cm, width 21 cm

The copper body has an applied rolled silver rim and silver base-plate with the *jungin* mark. The decoration is of two types of peony in silver *yūsen* with areas of *shōsen*, particularly on the stems. Set against a pale pink to beige ground, the petals and some of the leaves are in low-relief *moriage* with subtle shading both to the petals (white with a green and yellow centre) and the leaves (dark and light green enamels). The counter-enamel is of two tones: a mottled dark blue with matt white immediately inside the neck. The interior of the base has the mark of the Andō Company in silver *yūsen*.

Pair of vases

Nagoya; mark of the Andō Company
c.1912–26
Height 24 cm, width 16 cm

The copper bodies have applied silver rims and silver base-plates. The white ground is decorated in silver and brass *yūsen* and *shōsen* enamels: the red and blue thistles are outlined with wires and shaded with coloured enamels; the leaves are shaded in green enamels. Although the overall decoration is somewhat stylized, a naturalistic touch has been given by the depiction of insect damage to the leaves. The counter-enamel of the vases is of a matt brown colour, as are the inner base-plates, which have the silver *yūsen* mark of the Andō Company.

Vase

Nagoya, mark of the Andō Company
c.1912–26
Height 37.5 cm, width 20 cm

The copper body of the vase has an applied silver rim and silver base-plate with the *jungin* mark. The superbly executed decoration is of bush-clover (*Lespedza bicolour*; *Hagi* in Japanese), chrysanthemum, gentian and other flowers in silver *yūsen* on a blue enamel ground. The subtle shading of the flowers and foliage accentuates the vibrantly naturalistic composition, which spreads from the base to fill almost the whole of one side of the vase. The area below the rim has an abstract scrolling floral design in silver *yūsen* enamels and the foot is decorated with delicate and finely worked abstract geometric motifs in silver *yūsen*. The counter-enamel is of a matt brown colour, as is the inner base-plate, which has the silver *yūsen* mark of the Andō Company. The associated box carries the signature and seal of Andō Jūbei, as well as another seal indicating that the piece was made to imperial order.

Vase

Kyoto; mark of the Inaba Company
c.1912–26
Height 31 cm, width 14 cm

The vase has a copper body with an applied rim and base-plate, both of which have been enamelled over. Within the foot-ring there is a circular ring without enamelling, on which the vase would have stood during the firing process. The vase is unusual in that it is enamelled in a palette reminiscent of Dutch Delft pottery. The shape of the vase, which is also found in Delft ceramics, has a distinctly Chinese quality; the thickly applied *musen* shaded blue and white enamel decoration of floral motifs and geometric patterns are not, however, of Chinese origin, nor are they obviously European. The inner foot-ring carries the mark of the Inaba Company of Kyoto. The vase can be dated to around 1920 (private communication from Mr Inaba Katsumi). It is not clear whether this rather exotic vessel was intended for the Japanese or the foreign market. The associated box for this piece carries the signature and seal of the Inaba Cloisonné Company.

Vase

Kyoto; mark of Namikawa Yasuyuki

c.1890

Height 10 cm, width 5.5 cm

The copper body of the vase has an applied silver-gilt rim and silver base-plate. The ground consists of alternating silver and brass *yūsen* panels of blue-black and speckled aventurine green enamels. The ground is overlaid with a design of flowers, *karakusa* scrolls and butterflies in shaded *yūsen* and *shōsen* enamels. The stylized floral roundels are made up of convolvulus, paulownia (*kiri* in Japanese) and iris. The neck and area above the foot-rim have borders of stylized flowers and scrolls on a *chakinseki* ground. A silver plaque with the engraved four-character mark *Kyoto Namikawa* has been applied to the gilt base. For a tea caddy by Yasuyuki with similar decoration, see Plate 38; for a vase with similar decoration, see Fairley, *Japanese Enamels of the Meiji Era* (1998), no.9.

Dish

Tokyo; seal of Namikawa Sōsuke
c.1900
Height 24 cm, width 29 cm

The copper body of the dish, whose shape is reminiscent of the non-folding Japanese *uchiwa* fan, has a *shakudō* rim and a grey enamel ground. The bird, quite possibly a tree sparrow, has been sensitively depicted in silver *yūsen* and *shōsen* enamels using a combination of various shades of black, white, brown and grey to recreate the effect of an ink painting. The snow-covered pine bough with pink plum blossoms and buds has been rendered in a very painterly manner in shaded *yūsen* and *musen* polychrome enamels. Two green pine needles emerge from the bottom left corner of the dish. The back is covered with gold *yūsen* enamelled petals of plum blossom in two shades of brown on a matt dark brown ground and has the silver *yūsen Sakigake* seal of Namikawa Sōsuke. Although the composition of the bird on the branch is unsigned, it is likely to have been based on a brushwork design of an artist such as Watanabe Seitei.

Vase

Nagoya; mark of the Andō Company
c.1950–60
Height 31 cm, width 15 cm

The vase has a copper body with an applied silver rim and silver base-plate, which has the *jungin* mark. The rich dark green ground is decorated with large-headed yellow and white narcissi in a combination of shaded silver *yūsen*, *shōsen* and *musen* enamels. The faint colours of the flowers and the vanishing stems have an almost ethereal quality. The decoration is distinctly modern in feel and does not follow or imitate any recognizable traditional Japanese style. The matt counter-enamel is of a similar colour to the ground of the vase; the same enamel has been applied to the base, which has the mark of the Andō Company in silver *yūsen* enamels.

Vase

Nagoya; mark of the Andō Company
c.1930–50
Height 23 cm, width 17 cm

The copper body has an applied silver rim and silver base-plate, which is marked 'SILVER' in English. The flower depicted on the vase is known as the *Hōsōge* (an abbreviation of *Hōsōgemon*, literally 'precious flower pattern') and is associated with Buddhism. The *Hōsōge* combines aspects of the peony, the lotus and other flowers into a unique composition frequently linked with *karakusa* scrolls, as seen on this vase. The stylized design, which has a distinctly Art Deco feel, has been executed in shiny black *musen* enamel with silver *yūsen* to define the petal structure. The sinuous curves of the *karakusa* are softened by shadowy grey *musen* enamels, and the whole design, which occupies only one side of the vase, is on a pale yellow ground. The counter-enamel is of the same hue as the main ground and has also been applied to the base, which has the mark of the Andō Company in gold *yūsen* shaded brown enamel. Although the vase would no doubt have appealed to foreign buyers, its subject matter suggests that it was more probably made for the domestic market.

Openwork vase

Nagoya; mark of the Andō Company
c.1905–15
Height 31 cm, width 19 cm

This fascinating vase is made up of two separate components joined at top and bottom by an applied silver rim and silver base-plate, which carries the *jungin* mark. The outer section consists of a copper body pierced to form an outline of narcissi. The upper neck has a beige ground enamel. The narcissi have been executed in a combination of *yūsen* (silver for the flowers and gilded brass for the leaves) and *moriage* enamels (the leaves have a raised and rounded surface), as well as some shading on the petals and some of the leaves. The counter-enamel is of a very shiny brown. The central section consists of a hammered copper tube with a silver-gilt finish on the exterior and matt-brown counter-enamelling. There is a gold *yūsen* mark of the Andō Company on the dark brown enamelled base. A very similar design of narcissi is published in Watanabe Seitei's *Seitei Kachō Gafu* of 1891. The associated box for this vase has various inscriptions on paper labels. One describes the narcissi decoration; a second, probably more recent label, states that the vase was 'Honourably given to Mr Kujō', and, somewhat unbelievably, that it was made by Namikawa Sōsuke.

Dish

Tokyo; mark of Namikawa Sōsuke
c.1890–1900
Diameter 27 cm

The five-lobed dish echoes the shape of the petals of the plum blossom with which it is decorated. The copper body has an applied *shakudō* rim. The subject depicted is after an original by Watanabe Seitei, whose signature and seal are applied in black and red as on a painting. The design is of two birds on a flowering plum bough with bamboo leaves subtly intruding into the composition. The birds have been executed in softly shaded *yūsen* and *shōsen* enamels, as have the blossom and bamboo leaves. The branches of the tree, however, have been executed in *yūsen* and *musen* shades of black and grey enamel to imitate the brush-strokes of an ink painting. The greyish-brown ground is typical of dishes by Sōsuke. The back of the dish is covered with *yūsen* petals of plum blossom in two shades of grey-brown on a matt dark brown ground and bears the *Sakigake* seal of Namikawa Sōsuke in silver wires.

This type of dish demonstrates the standardization of shape, rim, body enamel and decoration of the back that can be found in Sōsuke's output. While he produced many fine individual works, he was clearly not averse to a production-line form of manufacture that responded to the demand for cloisonné at its peak. This aspect of Sōsuke and his enterprise was commented on by several Western observers including Brinkley: 'the Kyoto Namikawa is himself an expert of the highest skill; the Tokyo Namikawa is only an enterprising and resourceful employer of experts' (Brinkley, *Japan* 1901, p.376, note 57).

Pedestal vase

Nagoya; mark of the Andō Company
c.1920–40
Height 20 cm, width 20.5 cm

The two-part copper body (bowl and pedestal) has an applied silver rim and silver base-plate with the *jungin* mark. The decoration is of a stylized, Art Deco-influenced band of silver *yūsen* dandelion (*tampopo*) in low-relief *moriage* green and orange enamel on a speckled matt dark green and brown ground. The foot is decorated with a scrolling band of leaves and silver *yūsen* purple flowers. The counter-enamel is of a similar colour (although not speckled) to the body: this enamel has also been applied to the base, which has the gold *yūsen* mark of the Andō Company. The vase is extremely elegant and simple in both form and design, and would have been equally acceptable in a fashionable Japanese home, many of which had Western-style rooms by the 1920s, as in a non-Japanese environment.

Lidded vase

Kyoto; mark of Namikawa Yasuyuki
c.1890
Height 10 cm, width 8 cm

This small lidded vase has a copper body with an applied gold rim and base-plate. The lid is extremely heavy for its size and has a gold knob in the form of a lotus bud. The lid is decorated in *yūsen* enamels with stylized flowers within geometric panels. The main body of the vase is decorated with silver and gold *yūsen* enamels on a mirror-black ground. The three panels of speckled brown enamel contain, respectively, an extraordinary stylized Chinese-style dragon, a mythical *Hō-ō* (phoenix), and peonies and butterflies. These are all executed in finely detailed silver *yūsen* enamels. The areas between and overlapping the panels are decorated with various flowers including chrysanthemums, *Hōsōge* and *karakusa* scrolls in silver *yūsen* enamels. The shoulders are decorated with stylized geometric panels containing identical butterflies. The foot has fine *yūsen* enamel decoration of stylized petals. The counter-enamel of both the lid and the vase are a dark green to turquoise colour. The base has an applied silver plaque with the engraved four-character mark *Kyoto Namikawa*. This has been rather poorly made and the characters badly engraved, particularly the first character of 'Kyoto'.

The decoration of the vase is also a little stiff for Yasuyuki: it is known that, following his great success as a maker, signed copies were made of his work. These reservations aside, this vase is very likely to be an original by him: there is, for example, a design for a very similar dragon by Yasuyuki on page 156 of the *Kyō Shippō Monyō-shū*. For another very similar dragon, see Fairley, *Japanese Art of the Meiji and Taisho Eras* (1999), no.12.

Pair of vases

Nagoya; mark of Hayashi Kodenji
c.1910
Height 24.5 cm, width 13 cm

The left-hand vase represents daytime and has a copper body with an applied silver rim, inner neck-ring and base-plate. The pale blue-green ground is decorated in silver *yūsen* enamels with purple and white irises and other flowers by a rocks and a stylized swirling stream. There is subtle green shading to the white irises. The right-hand vase depicts a similar scene but this time at night. Its copper body has an applied silver-gilt rim, inner neck-ring and base-plate. The design, set against a very dark blue enamel ground, is again of purple and white irises beside rocks and a swirling stream, but here executed in gold *yūsen*. Both vases have within concentric circles on their bases the engraved inscription *Dai Nihon Aichi Hayashi saku* ('made by Hayashi [Kodenji] of Aichi Prefecture, Great Japan') and the mark of Hayashi Kodenji.

Pair of vases

Tokyo; seal of Namikawa Sōsuke
c.1900
Height 15.5 cm, width 9.5 cm

The heavy copper bodies of these vases have applied blackened silver rims and base-plates. The bodies have the pale grey ground so favoured by Sōsuke and which is found on many of his pieces of this period. The elegant design of chrysanthemums has been executed in a free and natural manner in gold (or possibly brass) and silver *yūsen* and *shōsen* enamels. There is some superb naturalistic shading and modelling on the petals and leaves. The counter-enamel of both vases is of a matt dark brown colour. This is also to be found inside their bases, which carry the silver *yūsen Sakigake* seal of Namikawa Sōsuke.

The way in which the designs of the two vases complement each other when placed side by side suggests that they were intended to be displayed as a pair. For vases in a similar palette, see Fairley, *Japanese Enamels of the Meiji Era* (1998), nos 67 and 68.

Vase

Kyoto; mark of Namikawa Yasuyuki
c.1890
Height 15 cm, width 6 cm

This small vase has a copper body with an applied silver rim, inner neck-ring and base-plate. The decoration is of silver and gold *yūsen* enamels depicting birds and flowers (including a flowering magnolia) on a mirror-black ground. While the composition is a little stiff and formal, the use of space is sensitive and the enamels have been applied with great skill. The area immediately below the rim has a delicate border of cicada-wing lappets, while the neck is decorated with geometric diaper panels and the shoulders with alternating butterflies and flowers on a brown enamel ground. The area above the foot has a band of stylized silver *yūsen* flowers within formal panels. The gilded inner base has an applied silver plaque with the engraved four-character mark *Kyoto Namikawa*. The birds on the vase are probably the Siberian blue robin (*Erithacus cyane*), a common summer visitor to Japan.

Vase

Tokyo; seal of Namikawa Sōsuke
c.1900
Height 19 cm, width 8.5 cm

The heavy copper body has an applied *shakudō* rim and base-plate. The gold *yūsen* and *musen* enamel design of *Shidare Zakura* (hanging, or weeping, cherry blossom) is applied to one side of the vase only and, interestingly, the design begins immediately under the rim. The simplicity of the design and the careful use of space are unquestionably Japanese in taste, while the warm grey ground complements the subtle shades of white, pink and grey of the cherry blossom. The counter-enamel is of a dark, almost matt brown colour. This enamel is also used on the base, where the *Sakigake* seal of Namikawa Sōsuke has been added in raised silver *yūsen*. The wires of the seal appear to have been covered with a transparent enamel. *Shidare Zakura* are found, often planted singly, at temples and shrines throughout Japan and are held in high regard, many of them being of a great age. As with many examples of Sōsuke's work, this piece would have appealed to both the domestic and the overseas market. For an almost identical piece, see Coben and *Japanese Cloisonné* (1982), plate 104.

Group of lidded vases

Kyoto; each with the mark of Namikawa Yasuyuki
c.1880–90
Height 11 cm, width 6 cm (smaller vases);
height 14 cm, width 9.5 cm (central vase)

Although these three vases do not constitute a set as such, the designs on one side are so similar in terms of colour scheme and layout that they have been grouped together here. The bodies are of copper and each has an applied gold rim, inner neck-ring and base-plate. The central panels in the first illustration are decorated with butterflies and summer and early autumn flowers in silver and gold *yūsen* enamels on a mottled brown ground. The flowers on the larger, central vase include pink hollyhock and what would appear to be a form of *Sorbus* (mountain ash) with red berries. The flowers on the smaller vases have not been positively identified but may include a type of aster. The larger vase has formal *shippō* motifs surrounding the central panel. The panels of each of the vases are surrounded by stylized flowers in *yūsen* enamels on a coloured enamel ground with areas of *chakinseki*. Designs very similar to the central panels can be found on pages 148–50 of Tessen Nakahara, *Kyo Shippō Monyō-shū* (1991). All three vases have Namikawa's mirror-black ground. The lids (which have solid gold knobs in the form of lotus buds), shoulders and lower sections of each of the vases have finely applied *yūsen*-coloured enamels depicting stylized flowers and geometric formal panels. Parts of the ground of the upper areas of the vases are executed in *chakinseki*.

The central panels shown in the second illustration are quite different. While the two smaller vases continue the theme of late summer or early autumn (with flowers such as chrysanthemum and gentian) on a sombre, speckled brown ground, the panel of the larger vase has a description of the mythical *Hō-ō* (phoenix) on a dark cream, slightly

speckled ground. The *Hō-ō* is superbly fashioned in silver and gold *yūsen* polychrome enamels with *chakinseki* details, and is surrounded by *Hōsōge* flowers and *karakusa* scrolls. The bird seems almost to float within the panel and is far less formal in execution than other examples of *Hō-ō* produced by Namikawa, for example the designs on pages 123–4 of Tessen Nakahara, *Kyō Shippō Monyō-shū* (1991).

The engraved, rather formal signatures on the smaller vases read *Namikawa Zō* (made by Namikawa); the more freely engraved signature on the larger vase reads *Kyoto Namikawa Zō* (made by Namikawa of Kyoto). The signatures are engraved directly into the base-plates on all three vases. For a vase by Yasuyuki of different shape but with a central panel of almost identical design to the larger vase, see Fairley, *Japanese Works of Art* (2004), no.42. For other vases decorated with similar designs and colour schemes, see Meiji no Takara, *Treasures of Imperial Japan* (1994), nos 5 and 6 (no.6 also illustrated in Barry Davies Oriental Art, *Japanese Enamels of the Golden Age*, 1990, no.21); for a pair of jars with a similar design of *Hō-ō* birds, see Earle, *Splendors of Imperial Japan* (2002), no.23.

Vase

Nagoya; unsigned but probably by the Andō Company
1960 or later
Height 25 cm, width 9.5 cm

This tall copper vase has an applied chrome-plated rim and base-plate. The design of chrysanthemum flowers and leaves has been executed in the technique called *tsuiki-jippō*, where the design is hammered into the body and then covered in silver foil prior to enamelling. In this case, the vase has been decorated in various shades of green, white, yellow and purple transparent enamels. The matt dull brown counter-enamel, which is also used inside the foot, is often associated with the Andō Company of Nagoya, which still produces very similar work today.

Vase

Nagoya; mark of the Andō Company
1960 or later
Height 23.5 cm, width 17 cm

The heavy copper body has an applied silver rim and base-plate with the *jungin* mark. The rich green enamel ground is decorated with a silver *yūsen*, *shōsen* and *musen* design of roses in shades of green and white enamel. The wires form part of the outline of the petals, the enamels being subtly shaded to create a three-dimensional effect, which is accentuated by the shadowing around the flowers. The counter-enamel is similar in colour to the ground and is also applied to the foot, which bears the silver *yūsen* mark of the Andō Company of Nagoya. The company is still producing very similar work today. Clients can choose between different qualities of enamelling, as well as different materials for the rims and base-plates.

Dish

Kyoto; unsigned but attributed to Namikawa Yasuyuki
c.1890
Diameter 13 cm

The small copper dish has an applied silver rim and foot-ring. The decoration is of a butterfly in silver and gold *yūsen* enamels on a cream-coloured roundel within a border of rings of very small circles. This is surrounded by stylized scrolling chrysanthemums and larch leaves. The outer border of the dish consists of stylized flowers within polychrome enamelled geometric motifs highlighted with areas of *chakinseki*. The ground is of a mirror-black enamel, and the attention to detail and the quality of the wiring are extremely fine. There is a design by Namikawa for another dish with a central butterfly and surrounding chrysanthemums on pages 187 and 191 of Tessen Nakahara, *Kyō Shippō Monyō-shū* (1991).

Lidded container

Kyoto; unsigned
c.1875–85
Height 8 cm, width 6.5 cm

This small copper-bodied vase, probably a tea caddy (*natsume*), has applied gilded rims, inner lid and base-plate. The lid and shoulders of the vase, which is in the shape of a *sake* jar, are decorated in enamels to represent a textile cover, here with exaggerated stylized folds, of the sort traditionally placed over such vessels. This area is decorated with brass *yūsen* flower petals and formal floral motifs in polychrome and green speckled enamels on a brown ground. The tight whorls of brass wires continue onto the lower part of the main body, which has a black enamel ground and is decorated with cranes and pines, both auspicious symbols in Japan. The area above the base-plate is decorated with formal geometric motifs. The counter-enamel is of a bright, matt green colour. Although unsigned, the vessel clearly shows the influence of Namikawa Yasuyuki.

Vase

Nagoya; mark of the Andō Company
1930–50
Height 37 cm, width 18 cm

The copper body has an applied silver rim and base-plate with the *jungin* mark. The soft beige-coloured ground is decorated with gentiana (*rindō* in Japanese) in silver *yūsen* and *shōsen* enamels, with areas of the petals and some of the leaves in low-relief *moriage*. There is elegant shading to the blue and pink of the petals and similar shading to the browns and greens of the leaves and stems. The counter-enamel is of two shades: an overall dull green with dark brown visible just inside the neck. The latter enamel has also been used on the inner base, where the silver *yūsen* mark of the Andō Company has been applied. For another illustration of this vase, see Fairley, *Japanese Enamels of the Meiji Era* (1998), no.55.

Vase

Nagoya; mark of the Andō Company

c.1910–20.

Height 24 cm, width 14 cm

The copper body has an applied blackened silver rim and silver base-plate with the *jungin* mark. The deep blue (almost purple) enamel ground is decorated with flowering and trailing paulownia (*kiri*). The stylized flowers have been executed in silver *yūsen* and *tōtai-jippō* translucent enamels in shades of orange, white and purple. The leaves, which are more naturalistic in appearance, are executed in exquisitely shaded silver *yūsen* green enamels. The treatment of the flowers and leaves and their placement against a large expanse of shiny black create a simple yet effective composition. The counter-enamel is the same shade as the exterior, although less polished, and the base has a matt olive-coloured enamel with the applied silver *yūsen* mark of the Andō Company. Paulownia has a special significance in Japan, where its leaves and flowers were historically used as the family crest of the imperial family and later of the military shōgunate. For another illustration of this vase, see Fairley, *Japanese Enamels of the Meiji Era* (1998), no. 54. For another vase by Andō Jūbei of similar shape and technique, see Coben and Ferster, *Japanese Cloisonné* (1982), plate 1.

Vase
Kyoto; the mark of Namikawa Yasuyuki
c. 1875–80
Height 10.5 cm, width 5 cm

The copper body has an applied silver rim, neck-ring and deep, footed base-plate. The turquoise enamel ground is decorated with chrysanthemum, hydrangea, gentiana (just visible on the lower right) and iris (just discernible on the left) in silver *yūsen* polychrome shaded enamels. The flowers represent all the seasons except winter. The neck is decorated with geometric floral *shippō* motifs, and the shoulders with stylized paulownia (*kiri*) leaves, *karakusa* scrolls and a geometric band. The base carries a silver plate engraved with the four-character signature *Kyoto Namikawa*. The simple shape and muted colours of this vase are representative of Yasuyuki's early work.

Bowl

Nagoya; mark of the Andō Company
c.1912–26
Height 8.5 cm, diameter 23.5 cm

The copper body has an applied silver rim and base-plate. The interior is decorated in silver *yūsen* with flowering chrysanthemums and trailing leaves in shades of green and white enamels. The chrysanthemum petals are executed in *tōtai-jippō* translucent enamels in shades of blue, purple and white, with silver *yūsen* being used to outline the petals. The leaves have an almost three-dimensional quality and appear to float as if on water. On the exterior of the bowl the chrysanthemums are complemented by stylized brown paulownia (*kiri*) leaves in silver *yūsen*. The base, enamelled in a matt brown, has the silver *yūsen* mark of the Andō Company. For another bowl by the Andō Company decorated in a similar technique with chrysanthemum, see Fairley, *Japanese Enamels of the Meiji Era* (1998), no.53.

Vase

Nagoya, mark of the Andō Company
c.1930–40
Height 36 cm, width 24 cm

The copper body has an applied rolled silver rim and base-plate with the *jungin* mark. The pale grey-green ground, reminiscent of the work of Namikawa Sōsuke, has a silver *yūsen* design of flowering chrysanthemums. Shades of green, blue and brown have been used on the leaves to suggest the changing of the season. The counter-enamel is green, except for the visible area within the neck, which is dark brown. The latter has also been applied to the base, which has the silver *yūsen* mark of the Andō Company. Although the composition appears rather formulaic and lacks the spontaneity of the best of Andō's designs, the workmanship and considered use of space are nonetheless of a high quality. A paper label on the accompanying box has a long honorific inscription stating that the vase was given to 'Lord Kido by the current Emperor'. This probably refers to Kōichi Kido (1889–1977), Lord Keeper of the Privy Seal to Emperor Hirohito (reigned 1926–89). Kido was a member of the Japanese cabinet from 1937, but held this important post, which controlled access to the emperor, from 1940 to 1945.

Vase

Nagoya; mark of the Andō Company
c.1950–60
Height 25 cm, width 13 cm

The copper body has an applied silver rim and base-plate with the *jungin* mark. The matt black ground is decorated with a single silver *yūsen* orchid in subtle and sensuous (particularly the interior of the flower) shades of pink and white with yellow highlights. The lily's leaves are faintly depicted in the background using silver *shōsen*. The counter-enamel is a glossy black. The base carries the silver *yūsen* mark of the Andō Company.

Vase

Nagoya; mark of the Andō Company
c.1900–10
Height 29.5, width 10.5 cm

The copper body of the vase has an applied rim and base-plate of *shakudō* with an inner neck-ring of gilt bronze. The shaded peach-coloured ground is decorated in brass and silver *yūsen* enamels with two Java sparrows (*Padda oryzivora*; *Bunchō* in Japanese) flying above maple trees (m*omiji*) in late summer or early autumn. It is not known when this type of bird was introduced into Japan, but they have been well observed by the artist, who has accurately depicted their soft grey plumage, black caps, white cheeks and red beaks. The Java sparrow is not native to Japan, but birds have escaped from captivity and subsequently established a feral population. The maple leaves have been executed in subtle shades of green enamel. The branches of the maple are rendered in softly shaded grey and black *yūsen* and *musen* enamels. The early stamped mark of the Andō Company has been applied inside the gilt base-plate. It is not known who designed the scene depicted on this elegant vase, but the subject matter of birds and flowers (*kachōga*) was popular with many Japanese artists of the nineteenth century.

The associated box for this vase has an ink inscription that states that the piece is 'Japanese Fine Art Enamel' (*Nihon Bijutsu Shippō*) and specifies the maple and the species of bird. It also carries the signature of Andō Jūbei, while the interior has the original Andō Company label with an illustration of Nagoya Castle. The label proudly makes reference to, and has an illustration of, the gold medal that the company was awarded at the Paris Exposition of 1900.

Vase

Nagoya, mark of the Andō Company
c.1912–26
Height 34 cm, width 29 cm

The copper body of the vase has an applied silver rim and base-plate with the *jungin* mark. The pale grey-blue ground has been decorated with a fruiting persimmon tree (*Diospyros kaki*) in silver *yūsen* and *shōsen* enamels with *moriage* details in both low and high relief. The design (by an unknown artist) makes perfect use of the form of the vase. This, together with the superb handling of the enamels, make this piece a true tour-de-force. The shading of the enamels used for the persimmons and the curling leaves creates a composition that is simultaneously impressionistic and realistic. This is accentuated by the painterly use of enamels on the trunk of the tree. The counter-enamel is dark brown. The same enamel has been used on the inner base, which has the silver *yūsen* mark of the Andō Company. For another vase by the Andō Company decorated with *moriage* persimmons on a similar ground, see Meiji no Takara, *Treasures of Imperial Japan* (1994), no.55.

Dish

Tokyo, seal of Namikawa Sōsuke
c. 1890–1900
Height 24.5, width 29.5 cm

The copper body of the dish, whose shape is reminiscent of the non-folding Japanese *uchiwa* fan, has an applied *shakudō* rim and a shaded grey ground. The decoration is of a crow, possibly after an original ink painting by an artist such as Watanabe Seitei, on a snow-covered pine tree with Mount Fuji in the distance. The bird has been portrayed in a combination of brass *yūsen* and *shōsen* shades of black, grey and white to emulate the brushstrokes of an ink painting. The snow-covered pine bough has been executed in *yūsen* and *musen* shaded enamels. The trunk of the tree is rendered in faintly shaded enamels, the shape being intimated in an impressionistic manner. In the distance the outline of Mount Fuji emerges through mist, its faint details being rendered in *musen* enamels. The back of the dish is covered with gold *yūsen* plum-blossom petals in brown enamel on a matt dark brown ground and carries the silver *yūsen Sakigake* seal of Namikawa Sōsuke.

Mount Fuji was a traditional, almost iconic motif that was extremely popular with Westerners at the time this dish was made. Indeed, it came to represent or symbolize Japan both for Japanese and Westerners. Sōsuke had famously made a large *musen* enamel plaque depicting the peak of Mount Fuji rising through clouds, which he exhibited at the World's Columbian Exposition in Chicago in 1893. For another fan-shaped dish by Sōsuke with a misty view of Mount Fuji, see Earle, *Splendors of Imperial Japan* (2002), no.217, and Meiji no Takara, *Treasures of Imperial Japan* (1994), no.102.

Vase

Nagoya; mark of Hattori Tadasaburō
c.1900–10
Height 36 cm, width 27 cm

The copper body has an applied silver rim and base-plate. The dull olive-brown ground is decorated with a silver *yūsen moriage* design of morning glory (*Convolvulus*). The sensitive use of space combined with the expert application of shaded enamels makes for a simple yet highly effective composition. The counter-enamel is of a matt green. The silver base-plate carries the stamped two-character seal *Tadasaburō* inside a *daikon* (a type of large radish) cartouche. The associated box for this vase has an ink inscription dating it to the fortieth year of the reign of the Emperor Meiji (equivalent to 1907) and stating that it was made by the 'Society of Carvers as a Gift to the Imperial Household'. A label on the box describes the piece as a 'copper bodied vase with a *moriage shippō* decoration of Morning Glory'. The textile lining of the box has the red ink seal of Hattori Tadasaburō. For a pair of vases in the collection of the Andō Company, which were also made by Hattori Tadasaburō and are decorated in a similar technique and colour palette, see Coben and Ferster, *Japanese Cloisonné* (1982), plate 132.

Pair of vases

Nagoya, mark of Hattori Tadasaburō
c.1900–10
Height 12 cm, width 6.5 cm

The copper bodies of the vases have applied silver rims, silver-gilt inner neck-rings and silver base-plates. Each vase has a design of little egrets (*Egretta garzetta*) in *musen* and white and grey *moriage* in low relief (the edges of the egrets are raised above the body of the vases). The ground is of a flambé-style enamel. The two-character mark *Hattori* has been engraved directly into the silver-gilt interior of the base. The tentative nature of the *moriage* on these vases may well represent one of the first steps in the development of this technique by Hattori, to whom its invention is often credited.

Vase

Unsigned; Nagoya-style, possibly Andō Company
c.1912–26
Height 28 cm, width 19 cm

The copper body of the trumpet-shaped vase has an applied silver rim and base-plate. The dull beige ground has been decorated with shaded white and green enamel orchids in silver *yūsen*. Details of the leaves and flowers have been finished in gently raised *moriage*. An interesting aspect of this vase, which unfortunately cannot be seen in the photograph, is that the long leaf on the left continues up and under the silver rim and into the interior of the vase. A gold *yūsen* enamel wasp with long rear legs hovers near the plant. Although the vase is unsigned, its shape, decoration, enamelling and colour palette are all indicative of Nagoya work, most likely that of the Andō Company.

Vase

Kyoto; possible mark of the Inaba Company
c.1890–1900
Height 12 cm, width 4.5 cm

The copper body has an applied silver rim and base-plate. The black enamel ground has been decorated in brass *yūsen* enamels with a tree sparrow (*Passer montanus*) perched on a flowering cherry. The leaves and parts of the flowers have been highlighted with shaded enamels to create a naturalistic effect, while the trunk of the tree has additional wires delineating and accentuating details of the bark. Just below the rim there is a band of geometric *shippō* motifs and around the foot are abstract floral lappets. The counter-enamel is green. This is also used on the interior of the foot, where an unusual brass *yūsen* mark, possibly that of the Inaba Company, has been applied.

Tazza

Nagoya; mark of Gonda Hirosuke
c.1912–26
Height 12.5 cm, diameter 24.5 cm

The two-part copper body has an applied silver rim and base-plate. The dark cream ground is decorated with a mythical *Hō-ō* (phoenix) in gold *yūsen* blue and brown enamels and a triple paulownia (*kiri*) leaf design in silver *yūsen* and *tōtai-jippō* translucent enamels of green and blue. The central motif in gold *yūsen* white enamel is a butterfly *mon* (family crest) of a type traditionally used in varying forms by many of Japan's ruling samurai families. The flowering paulownia had also been used as a crest by senior samurai families. The combination of the butterfly crest with the *Hō-ō* and paulownia – both of which have also long been associated with the imperial family – suggests that this elegant object was commissioned by an extremely important client. The inner base is enamelled a dark brown colour and carries the silver *yūsen* mark of Gonda Hirosuke. This mark is based on the character for *Haku* (white), the first part of the name of Gonda's Nagoya-based company, the *Hakuryūen* (White Dragon Garden). The accompanying box for this vessel has an ink inscription stating that it is a *shippō* vase decorated with an *agehachō*, a long-tailed butterfly. It also carries the red seal *Gonda Kinsei* ('respectfully made by Gonda'). The interior of the lid has the label of Gonda's company, the *Hakuryūen*.

Pair of vases

Nagoya; mark of the Andō Company

1912–26

Height 36.5 cm, width 23 cm

The copper bodies of these vases have applied silver rims and base-plates. The beige enamel ground is decorated simply with a wide central border of silver *yūsen* lilies (probably a type of day-lily, *Hemerocallis*) and leaves in varied shades of brown with white enamel highlights. The counter-enamel is of a dark brown, as are the inner bases, which carry the silver *yūsen* mark of the Andō Company. The vases have an associated box with the ink signature *Jūbei saku* (made by Jūbei) and the red seal of Andō Jūbei. There is also a paper label with the inscription *Jūbei saku*, together with a description of the lily decoration.

Vase

Nagoya; mark of the Andō Company
1912–26
Height 30 cm, width 20 cm

The copper body has an applied silver rim, a silver-gilt inner neck and a silver base-plate. The semi-matt pale aubergine ground has been decorated in silver *yūsen* with a trailing and flowering legume in shades of green and white enamels in low *moriage*. Areas of the flowers, bean-pods, leaves and stems are delicately raised above the surface of the vase to create an elegant, naturalistic and almost three-dimensional composition. The counter-enamel is of the typical matt dark brown associated with the Andō Company. This is also used dark on the base, where the mark of the Andō Company has been applied in silver *yūsen* and filled with white enamel.

Vase
Nagoya: mark of the Andō Company
c.1950–60
Height 31 cm, width 21 cm

The heavy copper body has an applied silver rim and base-plate with the *jungin* mark. The rich green enamel ground has a pale green *musen* design of peonies and leaves. The matt counter-enamel is of yet another shade of green. The inner base, which carries the mark of the Andō Company in silver *yūsen*, is enamelled in the same colour as the ground. The company is still producing very similar work today. Clients have the option of choosing between vases with rims and base-plates of real silver or chrome-plate.

Pair of imperial presentation vases

Nagoya; mark of Hattori Tadasaburō
c.1912–26
Height 30 cm, width 19 cm

The copper bodies of the two vases have applied silver rims and base-plates. The matt green enamel ground has a simple, rather formulaic, silver *yūsen* decoration of chrysanthemums with green leaves and yellow *moriage* petals. The neck of each vase has been decorated with the imperial chrysanthemum crest in gold *yūsen* and low-relief white *moriage* enamel. The counter-enamel is of a dull green colour. This has also been used on the inner base, where the four-character seal *Hattori Kinsei* ('respectfully made by Hattori') has been applied in silver *yūsen* and pale green enamel. Works specifically commissioned by the imperial household as gifts to specific individuals tended to be of extremely high quality. The vases illustrated here, although pleasing to look at and well crafted, are of slightly lesser quality than commissioned pieces and were probably not made with a particular recipient in mind.

Vase
Kyoto, mark of Namikawa Yasuyuki
c.1900-10
Height 15 cm, width 5 cm

The copper body of the vase has an applied blackened silver rim, neck-ring and base-plate. The shiny mirror-black ground has a brass *yūsen* (the wires of varying thickness) decoration of a bird (possibly a Java sparrow) on a flowering plum branch. The foot is decorated with a band of stylized bamboo leaves. A silver cartouche bearing the engraved four-character mark *Kyoto Namikawa* has been applied to the base. Many variations of this shape of vase and decorative palette were produced by Yasuyuki. There is a preparatory drawing of an almost identical vase on page 99 of Tessen Nakahara, *Kyō Shippō Monyō-shū* (1991). For a vase with an autumnal scene of a bird on maple which could be a pair to this vase, see Coben and Ferster, *Japanese Cloisonné* (1982), plate 92. For vases with similar designs, see also Impey and Fairley, *The Dragon King of the Sea* (1991), no.19, and Barry Davies Oriental Art, London, *Japanese Enamels of the Golden Age* (1990), no.10.

Vase

Nagoya; mark of the Andō Company
1920–40
Height 31 cm, width 17 cm

The octagonal vase has a copper body with an applied rim and base-plate, both of which have been enamelled over. The white enamel ground has been thickly applied to resemble tin-glazed earthenware. Within the foot-ring there is a circular ring without enamelling on which the vase would have stood during the firing process. The vase is enamelled in a palette reminiscent of Dutch Delft ware and is of a shape originally produced in Delft during the second half of the eighteenth century as part of five-piece garnitures (*kaststel*). Such vases were produced again during the later eighteenth century. The shaded blue *musen* enamel decoration of the panel shown here is of hunting dogs passing a church in a European landscape. The panel is surrounded by hybrid mixture of stylized grasses and floral motifs. The enamelled base carries the mark of the Andō Company in brass *yūsen*. As with the other Deft-inspired vase in the collection (page 93), it is unclear whether this rather exotic vessel was intended for the Japanese or the foreign market.

138 JAPANESE CLOISONNÉ: THE SEVEN TREASURES

Pair of vases

Nagoya; mark of Kawade Shibatarō
c.1900–04
Height 32 cm, width 17 cm

The copper bodies of the vases have applied silver rims, inner neck-rings (which continue for more than 5 cm inside the rims) and silver base-plates. The rich blue ground is decorated in silver *yūsen moriage* with plum blossom and boughs in polychrome enamels. The anthers and petals of the blossoms are gently raised above the surface of the vases, and the gnarled trunks and branches are in higher relief and shaded in hues of deep brown and green enamel. The bases of the vases have the two-character mark *Kawade* in silver *yūsen* within a red enamel double gourd on a blue enamel ground. The vases are displayed on what would appear to be contemporary lacquered wooden stands, although they are different from those on which they were originally exhibited (see photograph).

These vases were exhibited at the Louisiana Purchase Exposition of 1904 in St Louis, and were credited to Andō Jūbei with no mention of Kawade. The *Illustrated Catalogue of Japanese Fine Arts Exhibited in the Louisiana Purchase Exhibition* describes them as 'A Pair of cloisonné flower vase [*sic*], of plum-tree pattern, copper, by Andō (Jiubei), Aichi'. It is known that Kawade worked with or for Andō, and that some of his pieces carry his two-character mark in a gourd cartouche placed within the Andō mark. However, there are some objects, which seem by their execution and design to be Kawade's work, that carry only the Andō mark. For a single vase by Kawade Shibatarō of similar design and technique, see Meiji no Takara, (1994), no.40, and Earle, (2002), no.250.

Japan had both an official pavilion and a separate commercial exhibition at the Louisiana Purchase Exposition. The official catalogue of *The Exhibition of the Empire of Japan* lists among its extensive exhibitors as many as 89 cloisonné artists and companies. Japan's participation in world expositions had long been an important means for the country to demonstrate how well its arts and technology compared with those of the West. By 1904, however, there had been a distinct shift towards commercialism, and there was increasing concern about the actual sale of products from expositions.

Original illustration from 1904 St Louis catalogue.

Glossary

akasuke: a transparent red enamel sometimes called 'pigeon's-blood'

chakinseki: 'tea-dust' effect created by including a sprinkling of gold or brass dust in the enamel

ginbari: the technique of laying silver foil on an object before applying a coat of clear enamel

Hō-ō: a mythical and auspicious phoenix-like creature originally found in Chinese art and associated with Buddhism

Hōsōge: a mythical flower associated with Buddhism that combines aspects of the peony, the lotus and other flowers

jungin: literally 'pure silver', a mark found stamped on the base-plates of some cloisonné vessels

karakusa: literally 'Chinese grasses' and often shown as a scrolling motif on cloisonné

moriage: 'piled-up', the technique of applying enamels in layers so that they are in relief to the body of the vessel

musen: 'without wires', the enamelling technique where the wires are either completely hidden or are removed before the firing to create a softly outlined decoration

nanako: 'fish-roe' effect produced by hammering a metal body to produce a regular pattern of small dots

sakigake: 'pioneer', the mark used by Namikawa Sōsuke from about 1893

shakudō: an alloy of copper with a small percentage of gold which can be patinated to a blue-black colour

shippō motif: a geometric pattern based on four spindles arranged within a circle with ends touching, and sometimes enclosing floral motifs, diamonds or stars

shōsen: literally 'few' or 'limited' wires, the technique where the number of wires was kept to a minimum and used only to delineate details of a design

shōtai-jippō: 'eliminated body enamel', whereby the metal body of a vessel is dissolved after firing and polishing to create a stained-glass finish

tōmei-jippō: transparent or translucent enamel through which areas of the base metal, often chased, can be seen

tōtai-jippō: pierced body enamel, the technique where a design is cut into the body of a vessel prior to enamelling

tsuiki jippō: the technique where a design is hammered into the body and then covered in foil prior to enamelling

yūsen: 'with wires', the standard technique of creating cloisonné designs enclosed within wires

Bibliography

Alcock, Sir Rutherford, *Art and Art Industries in Japan* (London: Virtue, 1878)

Arts of East and West from World Expositions, 1855–1900, Paris, Vienna and Chicago (Tokyo National Museum, Osaka Municipal Museum and Nagoya City Museum, exhib. cat., 2004)

Barry Davies Oriental Art, London, *Japanese Enamels of the Golden Age* (exhib. cat., March 1990)

Blair, Dorothy, 'The Cloisonné-Backed Mirror in the Shōsoin', in *Journal of Glass Studies* [Corning Museum of Glass, New York] (1960), vol.II

Bowes, James L., *Japanese Enamels, with Illustrations from the Examples in the Bowes Collection* (Liverpool, 1884)

—, *Notes on Shippō* (London: Kegan Paul, 1895)

Brinkley, Captain F., *Japan: Its History, Arts and Literature*, vol.VII: *Pictorial and Applied Art*; vol.VIII: *Keramic Art* (Boston and Tokyo: J. B. Millett, 1901)

Coben, Lawrence A., and Dorothy C. Ferster, *Japanese Cloisonné: History, Technique and Appreciation* (New York and Tokyo: Weatherhill, 1982)

Earle, Joe, *Japanese Art and Design: The Toshiba Gallery at the Victoria and Albert Museum* (London, 1986)

—, *Splendors of Meiji: Treasure of Imperial Japan* (Broughton International, 1999) [catalogue of an exhibition that toured the USA]

—, *Splendors of Imperial Japan: Arts of the Meiji Period from the Khalili Collection* (Khalili Family Trust, 2002) [a variation on Earle 1986]

Fairley, Malcolm, *Japanese Enamels of the Meiji Era* (exhib. cat., June 1998)

—, *Japanese Art of the Meiji and Taisho Eras* (exhib. cat., November 1999)

—, *Japanese Works of Art* (exhib. cat., November 2004)

Garner, Sir Harry, *Chinese and Japanese Cloisonné Enamels* (London: Faber & Faber, 1962; 2nd edn, 1970)

Girmond, Sybille, 'Die Rezeption Japans, Die Internationale Ausstellung von Arbeiten aus edlen Metallen und Legierungen in Nürnberg 1885', in *Osastiatische Zeitschrift*, Neue Serie (2002–3), nos 4–6

Glendinning & Co. Ltd, *Catalogue of a Large and Valuable Collection of Japanese Cloisonné Enamel from the Glasgow Exhibition, Offered by Mr K. Hayashi of Nagoya, Friday, 19 April 1912, at 7 Argyll Street, Oxford Circus, London*

Harada, Jirō, 'Japanese Art and Artists of Today, VI: Cloisonné Enamels', in *The Studio* (June 1911)

Harris, Victor, *Japanese Imperial Craftsmen: Meiji Art from the Khalili Collection* (London: British Museum Press, 1994)

Impey, Oliver, and Malcolm Fairley, *The Dragon King of the Sea* (Oxford: Ashmolean Museum, 1991)

Kipling, Rudyard, *From Sea to Sea and Other Sketches* (London: Macmillan, 1904)

Konjiki no Kazari, *Kazari in Gold: Japanese Aesthetics through Metalworks* (Kyoto National Museum, exhib. cat., 2003; curator Kubo Tomoyasu)

Kozyreff, Chantal, *Tradition et transition: le Japon de 1842 à 1912* (Brussels, 1998)

Kuwayama, George, *Shippō: The Art of Enameling in Japan* (Los Angeles County Museum of Art, 1987)

Meiji: Japanese Art in Transition (Haags Gemeentmuseum, exhib. cat., 1987)

Meiji no Takara, *Treasures of Imperial Japan: The Nasser D. Khalili Collection of Japanese Art*, vol.III: *Enamel* (1994)

Nagoya City Museum, *Hōgyoku Shippō* (2000)

Nakahara, Tessen, *Kyō Shippō Monyō-shū* (1991)

Namikawa Sōsuke, untitled publicity booklet datable to about 1896, in the collection of Malcolm Fairley

Ponting, Herbert, *In Lotus Land Japan* (London, 1910)

Salwey, Charlotte, 'Japanese Enamels', in *Transactions of the Japan Society: Eighty-Sixth Ordinary Meeting* (16 February 1906)

Seckel, Dietrich, and Helmut Brinker, 'The Cloisonné Mirror in the Shōsōin: Date and Provenance', in *Artibus Asiae* [Ascona, Switzerland] (1970), vol.XXXII, no.4

Shaffer, Coral, 'Enamelling in Japan: An American's Experience', in *Glass on Metal: The Enamellers Magazine* (1990), vol.9, nos 3–5

Shippō-chō Shippōyaki Art Village Inaugural Exhibition Catalogue (2004)

Shōsenkyō Ropeway Cloisonné Art Museum, Kōfu (exhib. cat., 1994)

Suzuki, Norio, *Nihon no Shippō* (Kyoto, 1979) [published on the occasion of an exhibition at the Suntory Museum, Tokyo]

—, 'Shippō', in *Nihon no Bijutsu* (1993), vol.3, no.322

The Modern Era of Shippō: Japanese Cloisonné (Museum of the Imperial Collections, Sannomaru Shōzōkan, Tokyo, exhib. cat., 2004)

Yoshimura, Moto, *Shippō – Kinsei no Shippō* (Kyoto: Maria Shobo, 1966)

Index

Page numbers in *italics* refer to illustrations.

Ahrens Company 23–24
Aichi 19, 23, 60, 82, 104, 139
akasuke 54, 68
Alcock, Sir Rutherford 12
Andō Company 6, 15, 27–28, 33, 45, 53, 54, 56, 58, 69, 77–79, 81, 84–85, 88–92, 97–99, 112–13, 116–17, 119–25, 127, 129, 132–34, 137
Andō Jūbei 27, 30, 33, 35, 45, 54, 92, 123, 132, 139
Ashikaga Yoshimasa 16

Bing, Siegfried 30
bottles *22*
Bowes, James Lord 12–14, 33
bowls *20, 62–63, 119*
 three-legged *46*
boxes *74*
Buddhism/Buddhist 30, 62, 98
Brinkley, Captain Frank 12, 19, 23
Byōdōin Temple, Uji 16

candlesticks *40*
Cao Zhao (Cao Mingzhong) 46
champlevé 17
Cherry-blossom viewing (*hanami*) 69
Chinese enamels 10, 14, 19, 21, 28, 40, *46, 52, 56,* 62, *93,* 103
containers, lidded *22,* 23, *35, 115*

Delft ware 93, 137
dishes 30, *32,* 72, *80–81, 100, 114, 126*
fruit *81*
Dixon, Frank 33
door pulls (*hikite*) 16, *16*
Dresser, Christopher 12, 30, *31*

East and West India Dock Company 30
eggshell (*qianjiang*) porcelain 56
Emperor Hirohito 120
exhibitions
 Exposition Universelle de Liège, 1905 44
 First National Industrial Exposition, Tokyo 1877 24
 Japan British Exhibition, White City 1910 33
 Louisiana Purchase Exposition, St Louis 1904 139
 Paris Exhibition 1878 24, 32, 72
 Paris Exposition Universelle, 1867 26, 29
 Paris Exposition, 1900 28, 123
 Philadelphia Exhibition, 1876 24
 Vienna Exhibition, 1873 23
 World's Columbian Exposition, Chicago, 1893 26, 28, 73, 126

Family crest (*mon*) 117, 131
firebox (*hibachi*) 30, *31*
food box (*jūbako*) 29

Garner, Sir Harry 12
Gilbert, W. S. 12
ginbari 41, 51, 140
Gonda Hirosuke 45, 56, 131

Hakuryūen (White Dragon Garden) 131
Hara Fuji *22*
Harada, Jirō 11, 15, 27
Hattori Tadasaburō 27, 127, 128, 135
Hayakawa Komejirō 54
Hayashi Kihyōe 42
Hayashi Kodenji 10, 23, 28, 38, 44, 60, 75, 83, 86, 104
Hayashi Shōgorō 21–23
Hayashi Tadamasa 32
Hayashi Tanigorō 79
Hirata Dōnin (Hirata Hikoshirō) 16
Hirata Harunari 17
Hirata School 16–17, 19
Hōgyoku Shippō (Jewel Enamels) 52
Honda Yosaburō 54, 68

Imperial Craftsman (*Teishitsu Gigei'in*) 26, 28
Inaba Company 15, 28, 50, 63, 64, 67, 71, 93, 130
Inaba Hiroyuki 28
Inaba Isshin (Nanahō) 28, *28*
Inaba Katsumi 28, 56
incense-burners (*korō*) 30, *31,* 52

Japan Society 14
Japanese Village, London 12, *12*

Kaji Satarō 27, 30, 52
Kaji Tsunekichi 19–21, *19,* 27, 62
Katō Hideo 64
Katō Toichi 69
Kawade Shibatarō 27–28, 53, 74, 139
Kawasaki Ship Building Company 52
Kawasaki Shōzō 28, 52
kettles 29, *29*
Kikuchi Yōsai 72
Kipling, Rudyard 24–25
Kōichi Kido 120
Kumeno Teitarō 51
Kyoto Shippō Kaisha 24

Londos & Co. 30, *31*

Meiji, Emperor 26, 127
The Mikado (Gilbert & Sullivan) 12
mirror 16
moriage 27, 33, 88, 99, 124, 127, 128, 135, 139
motifs
 abstract *29*
 Art Deco 78, 81, 98, 102
 bats 23, *31*
 birds 23, *29, 31,* 38, 48, 58, 72, 73, 75, 76, 79, 83, 86, 96, 100, 106, 115, 121, 126, 128, 130, 136
 butterflies *24,* 30, *32, 33, 34,* 42, 60, 103, 108, 114, 131
 clouds *16, 20,* 21, 23, *31, 34,* 75, 126
 dogs 137
 dragons *20,* 21, 30, *32, 34,* 47, 54, 79, 103
 ducks *24*
 fans 72, 96, 126
 fish 41, 44, 45, 55, 57, 68
 flowers, leaves and plants *16, 20, 21, 22, 23, 24, 29, 30–35,* 38, *40,* 42, *46,* 48–53, 58, 61, 64, 66, 67, 69–72, 74–78, 80–85, 88–127, 129–35, 137, 139
 geisha 69
 geometric *21, 22,* 23, *29,* 30, *32, 33,* 71, 118

Hō-ō (phoenix) *32, 33*, 49, 80, 103, 108–10, 131
Hōrai 29
horses 62
karakusa scrolls *20, 21*, 23, *29, 31, 35*, 46, 49, 98, 103, 110, 118
key-fret patterns 21
landscape 56, 86, 137
momiji 67, 123
Mount Fuji 27, 33,126
Nagoya Castle 23, 123
pagoda 69
philosophers *34*
quail 23, 40
rocks and stream 104
samurai *32*
sea-shells and seaweed *20*
shippō 29, 42, 118
shōchikubai (Three Friends of Winter) 48
trees *29, 31*, 48, 59, 96, 100, 108, 115, 123, 124, 130, 136
vines 52, 74
wasp 129
waves 21, 47
whales *32*
Muramatsu Hikoshichi 23
Murase Kinsaburō 57
musen 27, 41, 45, 56, 58, 72, 84, 93, 96–98, 100, 107, 113, 123, 126, 128, 134, 137

Nagasaki lacquerware 29
Nagoya Cloisonné Company 23, 24, 26
Nagoya School 83
nail covers, decorative (*kugi-kakushi*) 16, *16*
Namikawa Museum 26
Namikawa Sōsuke 8, 14, 26–27, 72, 96, 99, 100, 105, 107, 120, 126

shop sign 26
Namikawa Yasuyuki 24–26, *25*, 32, 33, *34*, 35, 60, 76, 94, 103, 106–10, 115, 118, 136
nanako 41, 44, 51, 54, 57, 68, 140
Nihon Dentō Kōgeiten (Exhibition of Japanese Traditional Art Crafts) 15

Ogasawara Shūzō 44
Ogasawara Takajirō 44
Okumura, Mr 56
Ōta Jinnoei 54, 68, 73
Owari 19

Perry, Captain Matthew 8
plique-à-jour (*shōtai-jippō*) 28
Ponting, Herbert 25–26

Qiu Ling 56

sakigake 27, 72, 96, 100, 105, 107, 126, 140
Salwey, Charlotte 14, 25
Seizaburō Gotō 32, *32*
Seven Treasures 10
shakudō 58, 74, 76, 96, 100, 107, 123, 126, 140
Shippō-chō / Shippō-mura 15, 23, 27
Shippōyaki Art Village 17, 21
Shōmyōji Temple, Nagoya 21
shōsen 27, 38, 41, 45, 56, 59–60, 63, 66, 67, 69, 72, 77, 82–85, 90–91, 96–97, 100, 105, 113, 116, 122, 126, 140
Shōsōin, Nara 16
shōtai-jippō *28*, 53,55, 63–64, 66–67, 69–71
Sparkes, John 33
specimens, cloisonné *18*
Suzuki Chōkichi 73
sword-guards (*tsuba*) 16, *17*

Tani Bunchō 56
tazza *131*
tea-jar (*natsume*) 22, *35*, *115*
Thesmar, Fernand 28
Tokugawa 19, 29
toolbox *19*
Tōshima 15, 23
tsuiki-jippō 112
Tsukamoto Jine'mon 23
Tsukamoto Jinkurō 26
Tsukamoto Jinsuke 26
Tsukamoto Kaisuke 21–23

vases 13, *33, 34, 38*, 41–42, 44–45, 47–51, 54–61, 64–71, 73, 75–79, 82–95, 97–99, 102–13, 116–18, 120–25, 127–30, 132–39
imperial presentation *135*
lidded 24, *102*, *108*
openwork 99
pedestal *102*
shōtai-jippō 28, 61, 64, 66, 69–71

Wagener, Gottfried von 8, 23–24
Wakon Yōsai 11
Watanabe Seitei 27, 72, 96, 99, 126
water container (*mizusashi*) 21
water-droppers (*suiteki*) 16, *16*

Xuande, Emperor 46

yūsen 27, 38, 40–42, 45–46, 48–51, 53, 55–57, 59–60, 63–64, 66–67, 69–86, 89–92, 94, 96–100, 102–108, 110, 113–120, 122–124, 126–127, 129–137, 139–140
yutō (hot water ewer) 11

zōgan 16